LONDON'S PLEASURE STEAMERS

Andrew Gladwell

AMBERLEY

First published 2015

Amberley Publishing
The Hill, Stroud
Gloucestershire, GL5 4EP

www.amberley-books.com

Copyright © Andrew Gladwell, 2015

The right of Andrew Gladwell to be identified as the
Author of this work has been asserted in accordance
with the Copyrights, Designs and Patents Act 1988.

ISBN 978 1 4456 4158 4 (print)
ISBN 978 1 4456 4172 0 (ebook)

British Library Cataloguing in Publication Data.
A catalogue record for this book is available from
the British Library.

Typeset in 9.5pt on 12pt Celeste.
Typesetting by Amberley Publishing.
Printed in the UK.

Acknowledgements

This book has been written to evoke the heritage and atmosphere of the well-loved pleasure steamers that plied their trade from London to the famous seaside resorts of Kent and Essex. This book intends to remember in particular the final and happy years of the famous 'Eagle Steamer' fleet, and reminisces on wonderful pleasure steamers such as the *Royal Eagle, Royal Daffodil, Royal Sovereign* and *Queen of the Channel*. In compiling this book, I have been grateful for the help, encouragement and co-operation of several individuals. In particular, I would like to thank Jean Spells, Jill Harvey and Kieran McCarthy. For more information about the cruises by the vintage excursion ship *Balmoral*, see www.heritagesteamers.co.uk/balmoral.

This book is dedicated to the late Peter Gladwell who enjoyed trips aboard the *Waverley* and *Balmoral* on the River Thames from London.

Introduction

For generations of Londoners, a trip to the seaside aboard a pleasure steamer such as the *Royal Eagle, Golden Eagle* or *Royal Daffodil* was the highlight of the year. The excitement of exploring the many luxurious and fascinating interiors aboard the ships combined perfectly with the on-board entertainment, fresh air and anticipation of what they would do at their destination resort. These 'poor man's liners' were an important part of family life for many Londoners.

The tradition went back to the 1820s, when the first commercial paddle steamers entered service. These were small wooden vessels with little covered accommodation for their passengers. They certainly lacked the grand facilities that would become commonplace at the end of the century. The steamers that followed in the footsteps of the *Comet* were limited due to their speed as well as having less landing facilities than in later years. Londoners initially visited places such as Gravesend with its impressive pleasure gardens at Rosherville. This attraction was closer to London and was therefore achievable by steamer in a day. Initially, there were many small companies that plied for trade on the London river and rivalry was fierce. The key player emerged early when the mighty General Steam Navigation Company was formed in 1824. They were to dominate London's pleasure steamers for more than a century until their demise in the mid-1960s.

By the mid-1860s, larger steamers were becoming the norm. Seaside piers, designed by talented engineers such as Eugenius Birch, were now being built longer so that the larger steamers could land passengers at all states of the tide. Victorian advances in technology and manufacture came together to provide the perfect platform for pleasure steamer services to thrive. Naturally though, the spread of the railways across the routes of the paddle steamers meant that an atmosphere of competition was created – in the end, both modes of transport existed side by side on the Thames. London became the transport hub of the Empire.

At the end of the Victorian era, piers and pleasure steamers had evolved to become glorious reflections of the Victorian age. Steamers had grand saloons and passenger facilities, combined with gleaming engines and fast speeds to provide a quick and luxurious means of transport to the seaside for Londoners. Piers were also at their most impressive, welcoming day-trippers to the seaside along exotic and amazing water-bourne promenades. London gave the pleasure steamers their greatest landmark when Tower Bridge was opened in 1894. It provided a spectacular sight for Londoners as it opened or closed for them on their day trip to the coast.

The first decades of the twentieth century witnessed a period of competition on the Thames as the General Steam Navigation Company saw rival companies such as the Belle Steamers and New Palace Steamers try and grasp some part of the lucrative market offered by London. New and popular steamers such as *Golden Eagle* and *Crested Eagle* had entered service, followed by the *Royal Eagle* in 1932, which entered service at London as the epitome of luxury for the Art Deco age. Just a few years later, the first of the new and revolutionary motor ships entered service. These were sleek, fast and luxurious vessels. London had never seen anything like them before. The glorious *Royal Daffodil* of 1939 was the last of these and perhaps became the most well-loved and famous of all of London's pleasure steamers.

After the Second World War, London soon saw pleasure steamers resume service to the coast once again and gleaming new ships were commissioned to replace wartime losses. The initial boom in trade caused by war-weary Londoners and demobbed servicemen was soon replaced by them wanting to go to Margate by motor car along the A2 rather than on a breezy and sometimes elderly pleasure steamer. Older vessels such as the *Golden Eagle* and *Royal Eagle* were soon withdrawn and it was abundantly clear that the three motor ships *Royal Sovereign*, *Queen of the Channel* and *Royal Daffodil* were far too large for the dwindling trade. The 1950s witnessed a dramatic change and, despite efforts to keep service alive, the mid-1960s saw London's pleasure steamer heritage grind to a halt when General Steam Navigation ceased operating on the Thames.

There were some valiant attempts by enthusiasts to operate old and unsuitable paddle steamers on the Thames in the early to mid-1960s but each attempt to revive services failed spectacularly. The 1970s became a time when it seemed that the chance to experience a traditional trip to the seaside from London by ship would never be possible again. However, in the late 1970s the famous *Waverley* visited London for the first time and instantly revived the tradition that was so beloved by generations of Londoners who enjoyed a day at Southend or Margate. She was joined by the well-loved *Balmoral* in 1986. Now in the twenty-first century, it's still possible to experience a cruise from London seeing all of the sights such as Tower Bridge, Tower of London, London Docks, Greenwich waterfront and the Woolwich ferries just as our forefathers in London did almost 200 years ago!

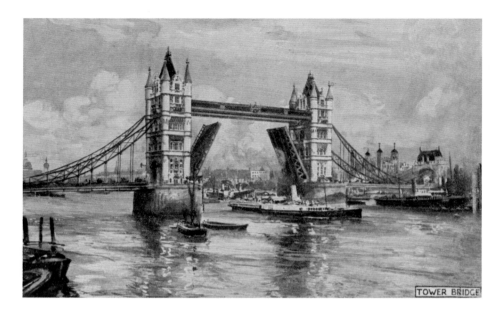

TOWER BRIDGE

Pleasure steamers first appeared on the River Thames during the 1820s. At that time, it was uncommon for Londoners to travel far from the city. Pleasure steamers enabled folk to visit places by river for the first time. As services developed, faster and more economical steamers entered service.

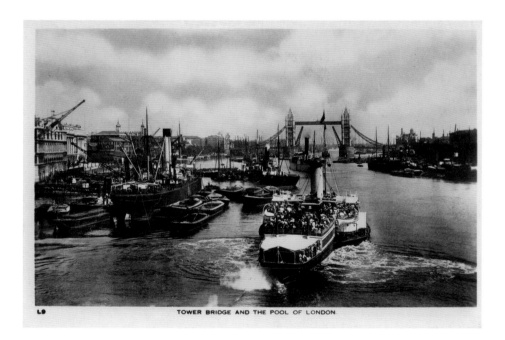

TOWER BRIDGE AND THE POOL OF LONDON

The Edwardian era saw Thames pleasure steamers at their most popular. It was a time when the operating companies could rely on vast numbers of passengers. It saw the most impressive and grand paddle steamers of all time grace the London River. This view shows the huge amount of boats and small craft that were in the Pool of London at the time. Negotiating a clear route was clearly a problem at times.

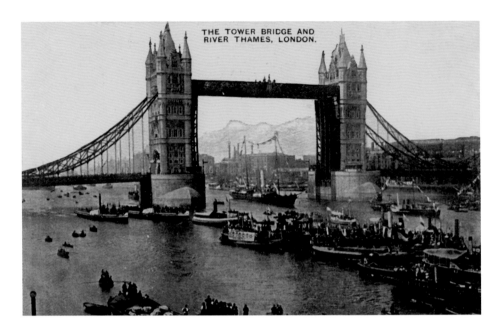

THE TOWER BRIDGE AND
RIVER THAMES, LONDON.

Tower Bridge opened in 1894 with the Royal Yacht entering under the raised bascules. Note that these are in a vertical 'royal' salute. *Balmoral* provided a number of memorable and highly popular cruises in connection with the centenary of Tower Bridge in 1994. The culmination of the celebrations was a spectacular fireworks display that lit up the London skyline.

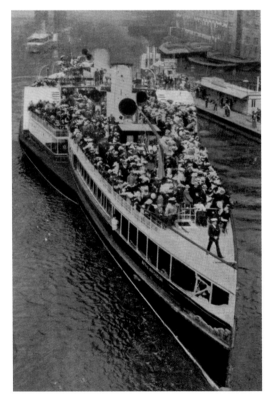

A crowded *Royal Sovereign* has lowered her funnels ready to pass underneath London Bridge. She was one of the largest of all Thames pleasure steamers and conveyed vast numbers of Londoners to the seaside during the heyday of paddle steamers. Old Swan Pier can be seen alongside her as she departs. Note the absence of deck houses that became more developed on vessels such as the *Royal Eagle*.

The Pleasure Lawn.
LOOKING WESTWARD.

Rosherville Gardens were created in 1837 by an Islington businessman named George Jones. They were built in a disused chalk pit at Northfleet. They became a hugely popular attraction for Londoners arriving by pleasure steamer as the gardens had their own pier.

The Botanical Garden.
LOOKING WESTWARD.

A general view of Rosherville Gardens in its early-Victorian heyday. The bear pit was a highly popular feature and has recently been uncovered. One of the steamers from Rosherville Gardens was involved in the famous *Princess Alice* disaster in 1878. Soon after departing from the pier, the *Princess Alice* was involved in a collision with the *Bywell Castle* close to Woolwich. Approximately 640 people died in the collision, with around 240 being children. After the accident, Rosherville Gardens faced a slow decline.

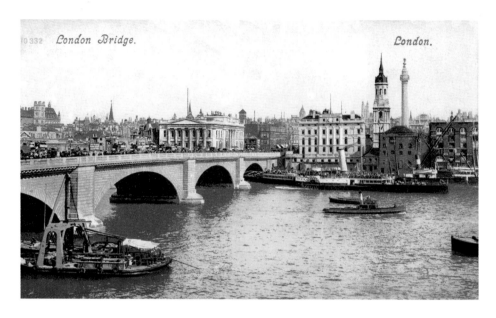

Tower Pier is only around eighty years old. Before it was built, paddle steamers had to use piers close to London Bridge. Here, a paddle steamer is shown in front of the church of St Magnus the Martyr. The position of the paddle steamer marks the spot where the old medieval London Bridge once stood. When its replacement (shown here) was opened in 1831, it was built slightly upriver.

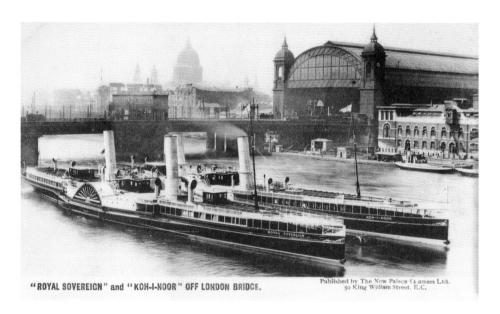

"ROYAL SOVEREIGN" and "KOH-I-NOOR" OFF LONDON BRIDGE.

Published by The New Palace Steamers Ltd.
50 King William Street. E.C.

The majestic-looking *Royal Sovereign* and *Koh-i-Noor* moored close to Old Swan Pier, with the vast roof of Cannon Street Railway Station in the background. You can appreciate the changing needs of Edwardian folk as all of the deck space has covered passenger accommodation. These were some of the largest paddle steamers ever built and they were introduced at a time of great competition on the Thames. Ultimately, this competition provided ever bigger and more splendid paddle steamers for Londoners to enjoy.

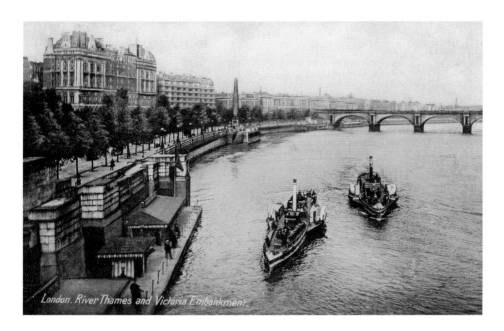

London. River Thames and Victoria Embankment.

The Edwardian period witnessed the largest number of paddle steamers that London has ever seen when the small but distinctive paddle steamers of the London County Council fleet joined the General Steam Navigation and Belle Steamers.

The final years of the Victorian and Edwardian eras marked a time when seaside resorts and paddle steamers reached their zenith. It was a time when all of the advances in technology and design combined with an increasing demand by ordinary Londoners to have at least one day a year at the seaside. Bank holidays had arrived for the first time in 1871 and by the 1930s Londoners were able to have paid holidays for the first time.

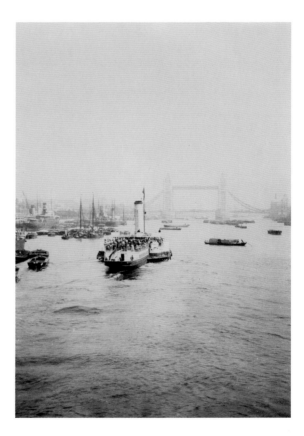

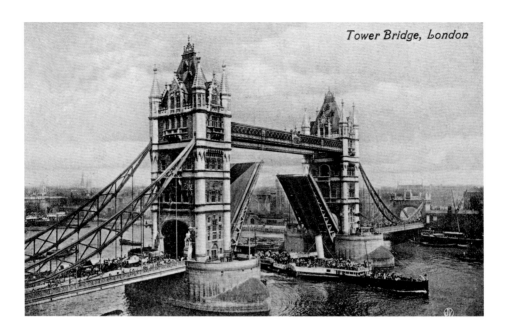

Tower Bridge, London

Tower Bridge was built to try and deal with the increasing amount of road traffic in Victorian times. The importance of London at the height of the British Empire meant that the world's greatest city required a highly developed road network in order to deliver goods and people. The bridge was built to help deal with this and its novel lifting-bascules meant that road traffic could be disrupted as little as possible when a pleasure steamer passed underneath.

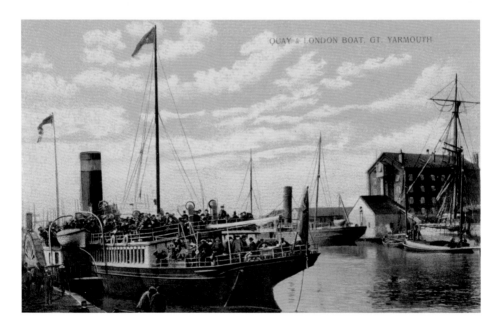

QUAY & LONDON BOAT, GT. YARMOUTH

Great Yarmouth was the farthest destination for a paddle steamer trip by Londoners. The Norfolk resort became very popular with Londoners during Edwardian times and passengers were able to reach it in a day. Postcards such as this always tend to show paddle steamers crammed with passengers.

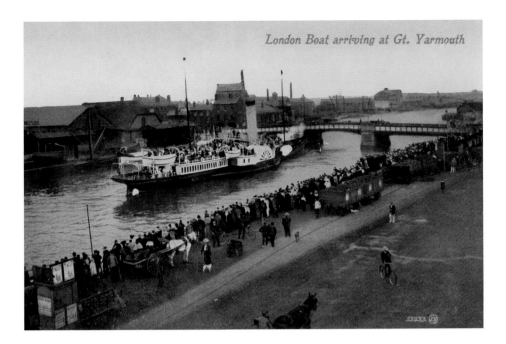

Trade to the Norfolk seaside resort of Great Yarmouth was lucrative for the late Victorian and Edwardian fleets. There was a great deal of competition between the Belle Steamer and General Steam Navigation fleets for the Norfolk and Suffolk trade.

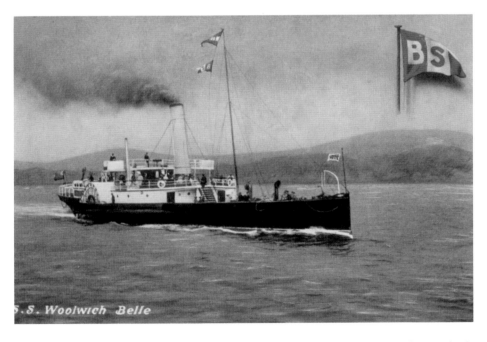

S.S. Woolwich Belle

Woolwich Belle was part of the famous Belle Steamer Fleet. All of the vessels were built at the famous Denny of Dumbarton shipyard and named after key destinations served by the steamers. Clacton was a key destination at the time and the Belle Steamer fleet was synonymous with the resort and its neighbours.

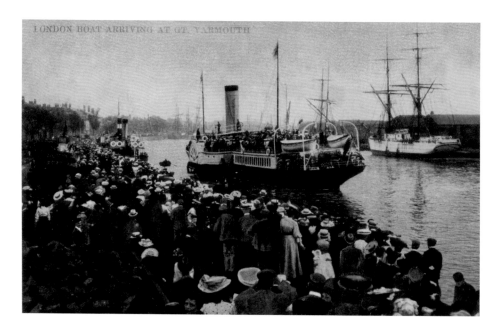

In Edwardian times, it was possible to travel to places that were quite remote from London. Great Yarmouth in Norfolk was one such destination that could be reached due to the building of fine and long piers at places such as Clacton and Walton. The Belle Steamer fleet became synonymous with these East Anglian routes. Just look at those huge queues of Londoners on the quayside ready to join the steamer for the journey back home.

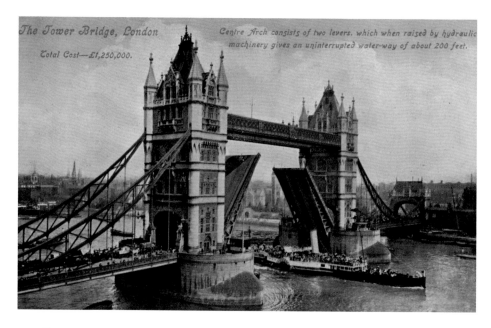

A Belle Steamer passing under the raised bascules of Tower Bridge during their heyday at the start of the twentieth century. The Belle Steamer fleet became one of the greatest threats to the supremacy of the GSNC fleet. Their threat only lasted for a short time; after the First World War, the fleet was dispersed and sold.

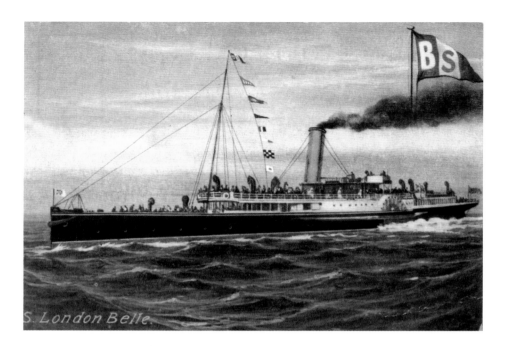

The Belle Steamer fleet were synonymous with Thames service at the end of the Victorian period and start of the Edwardian era. Their fine facilities, combined with vast number of destinations available from London, made them favourites with Londoners. The *London Belle* is shown here. She was built in 1893 and, at 280 feet in length, she was the largest pleasure steamer in the fleet.

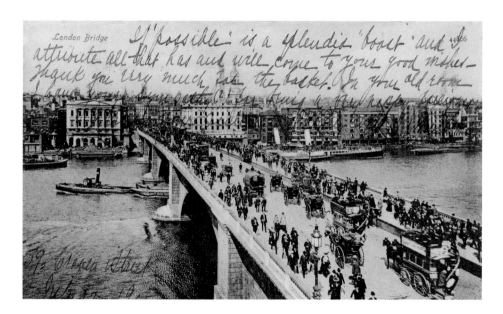

London Bridge with a paddle steamer alongside the pier around 1905. Services were rigorously marketed in Victorian times by various hawkers who promoted the wisdom of travelling on their services. This frequently led to brawls at Thames piers. London offered huge potential for operators of pleasure steamers.

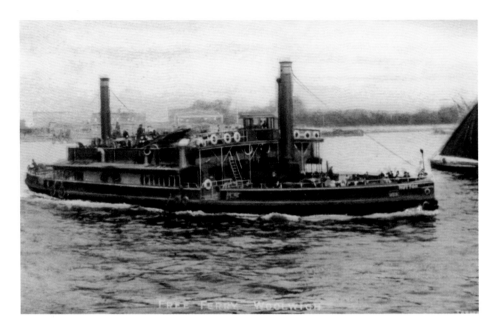

Woolwich ferries, such as the paddle-driven *Hutton*, always provided interest for Londoners on their day trips to the sea. The Woolwich ferry has always been free and it became the only means of a day out for many Londoners who were penniless. They must have looked on in awe as majestic steamers such as the *Royal Eagle, Golden Eagle* or *Royal Daffodil* made their way to the seaside at great speed.

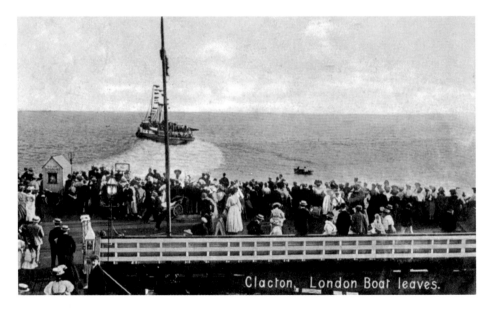

Clacton, London Boat leaves.

Londoners adored the seaside resorts of Southend and Margate as they gave them a long time ashore in which to enjoy the atmosphere of the seaside. Amusement parks such as the Kursaal and Dreamland were hugely popular. Further afield resorts such as Clacton were less popular due to the distance from London, but they provided an excellent link to London. The Belle Steamer fleet was firmly linked to Clacton.

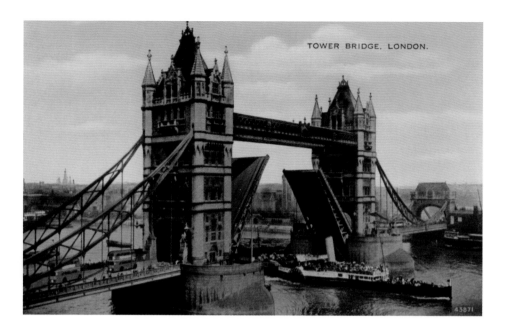

Londoners will notice that this view of Tower Bridge with a Belle Steamer was changed several decades later when they added two Routemaster buses from the 1950s! It only takes two minutes for the bascules to raise. Their elevation leaves a free height of 150 feet with a passageway width of 200 feet.

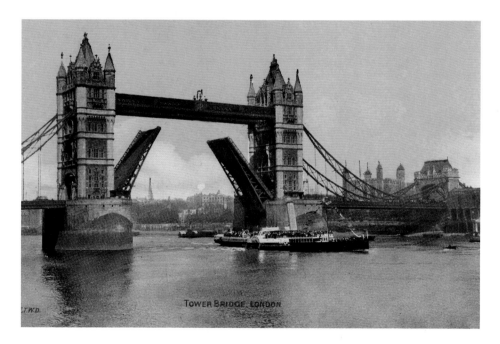

TOWER BRIDGE, LONDON

The Belle Steamer fleet featured in countless postcards showing Tower Bridge and the Tower of London during Edwardian times. Their presence on the Thames coincided with the postcard craze. Postcards showing them passing under the bridge were still being sold over three decades after the steamers disappeared.

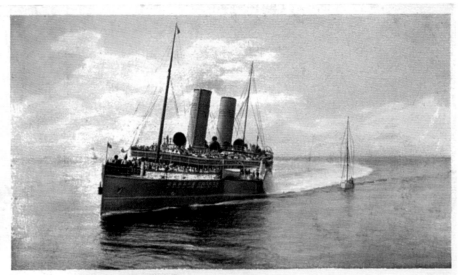

"La Marguerite" off SOUTHEND.

La Marguerite off of Southend Pier. She was one of the most majestic of Thames paddle steamers. Built in 1894, she was over 300 feet in length. She became the first Thames paddle steamer to offer trips to France and back in a day. Despite this, she was too large to be economic and soon left the Thames for service in North Wales.

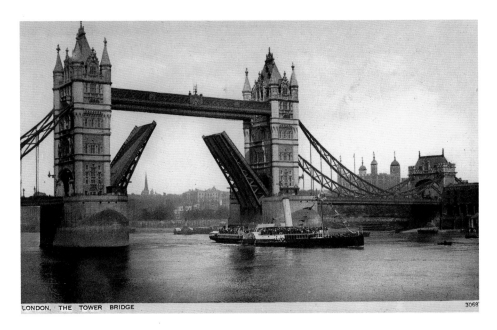

LONDON. THE TOWER BRIDGE 3068

The large tidal range of the Thames can be appreciated in this view as a paddle steamer passes under the bridge in Edwardian times. The pleasure steamer business was cut-throat, with tight schedules and ever-increasing passenger facilities to help the operators make the strongest possible profit.

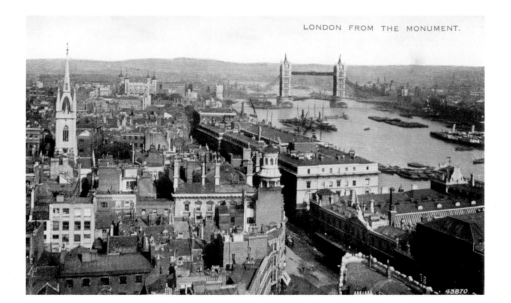

A view of the Pool of London from the Monument to the Great Fire of London. The view shows paddle steamers moored midstream, ready to move to Old Swan Pier for the next day's sailing. In many ways, this view is quite similar today as so many buildings are listed and also follow the same Roman street pattern. The biggest change is that several large and distinctive buildings such as the Shard and the Gherkin have changed the skyline.

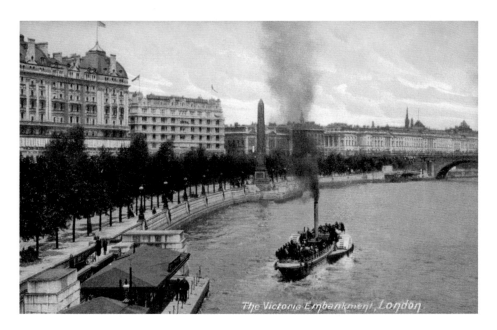

In Edwardian times, it was common to see a paddle steamer plying for trade in central London when the London County Council fleet operated. The view here has changed very little over the years. The first building is the former Hotel Cecil, next to that is the famous Savoy Hotel, and in the distance you can see Somerset House. Cleopatra's Needle is at the centre. It was transported from Egypt by the paddle steamer *Anglia*.

17

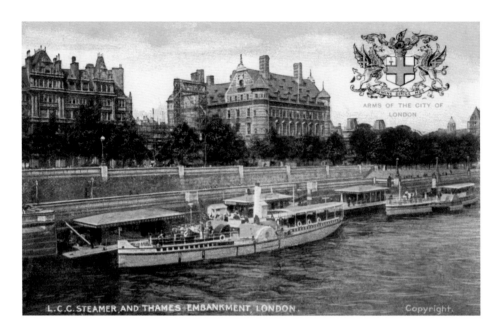

L.C.C. STEAMER AND THAMES EMBANKMENT, LONDON. Copyright.

A busy time as two paddle steamers of the London County Council fleet arrive at the Thames Embankment. It was an ambitious and well-conceived scheme, but ultimately faced disaster due to the competition of other more flexible and economic modes of transport, such as trams.

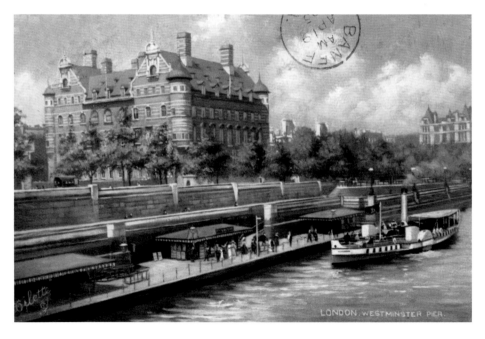

LONDON. WESTMINSTER PIER.

One of the London County Council paddle steamers arriving at Westminster Pier in Edwardian times. The steamers from this fleet were very distinctive. They were all very similar in size and had passenger accommodation that varied little from steamer to steamer.

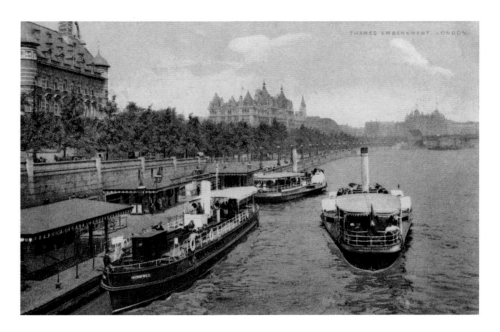

London County Council paddle steamers at Westminster Pier in Edwardian times. At this time, London had a huge number of paddle steamers that plied the river for trade. This was the peak of paddle steamers on the Thames at London.

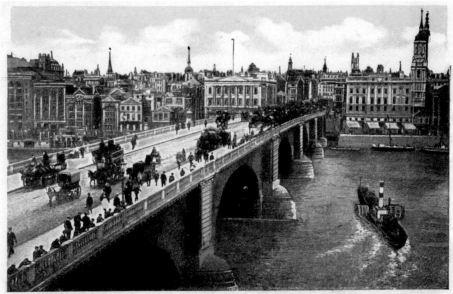

LONDON BRIDGE AFTER THE 1904 WIDENING Copyright G. D. & D. L

Almost thirty paddle steamers plied for trade between Hammersmith and Greenwich as part of the London County Council fleet. The service started in 1905 but was an almost instant failure as they had ceased operating by 1907. When services finished, fourteen were purchased by the City Steamboat Company. After this, a leaner fleet existed before services stopped at the outbreak of the First World War in 1914.

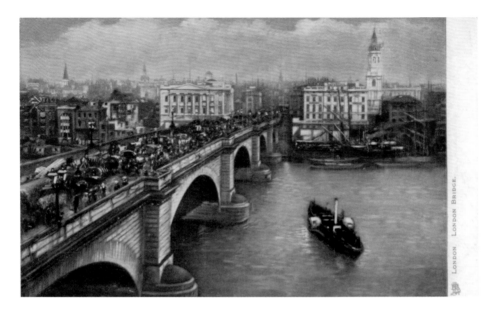

The small and distinctive fleet of London County Council paddle steamers proved a valiant attempt to introduce a ferry service linking London piers. The busy atmosphere of London Bridge contrasts starkly with the calm look to the river with its ferry. The idea of a Thames ferry became a success a century later when the fleet of modern Thames Clippers entered service between Westminster and Woolwich.

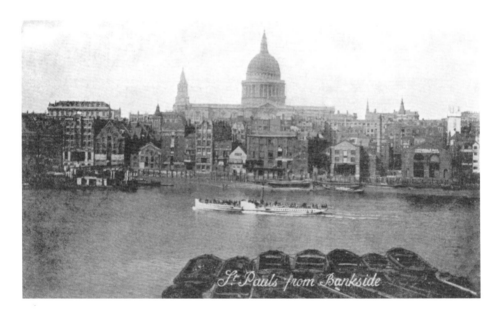

A London County Council paddle steamer is seen here in front of St Paul's Cathedral in around 1905. It's interesting to note the variety of the old riverside buildings and wharves, as well as the low height of buildings surrounding St Paul's Cathedral. For many centuries, it was illegal to build buildings above the height of St Paul's as fire fighting was impossible over that height. The position of the paddle steamer marks the position of the Millennium 'Wobbly' bridge that links the Tate Modern at Bankside with Wren's masterpiece.

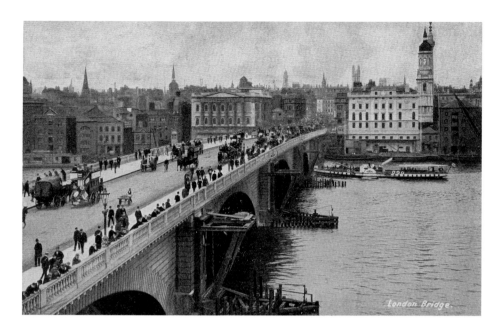

London Bridge in Edwardian times, with a London County Council paddle steamer lowering its hinged funnel to pass under the somewhat limited clearance of the bridge. The church of St Magnus the Martyr and the Monument boldly tower above all other buildings. Nowadays, *Waverley* and *Balmoral* regularly turn very close to London Bridge and, to many eyes, it looks like they might collide with the structure as the tug pulls them strongly.

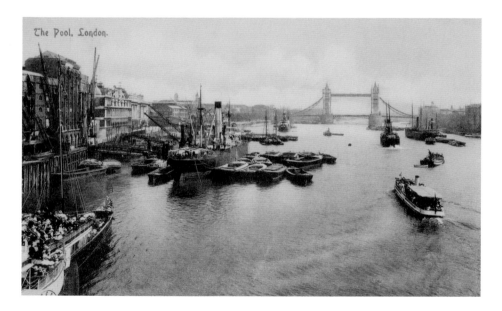

The Pool of London during its Edwardian heyday. Note the paddle steamer in the bottom left-hand corner that is full of passengers ready for a day at the seaside. This was in the time before Tower Pier was built. This area provided a huge market for paddle steamer trips as East Enders were able to easily access the pier. Note the pleasure boat midstream. Many of these craft had long careers on the Thames but were altered considerably later in their careers.

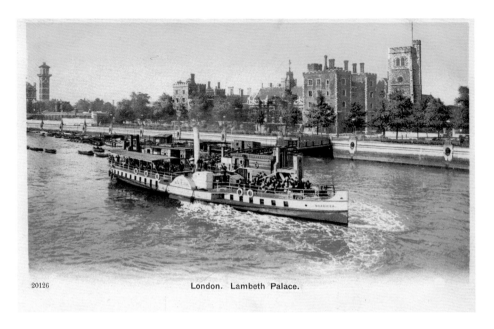

20126　　　　　　　　　　London.　Lambeth　Palace.

Boadicea is seen arriving at Lambeth Pier in Edwardian times. Along with her sisters, *Boadicea* was built when the Thames Steamboat Company took over the Victoria Steamboat fleet. She was built by the Thames Ironworks in 1898 and she survived with the fleet until 1912.

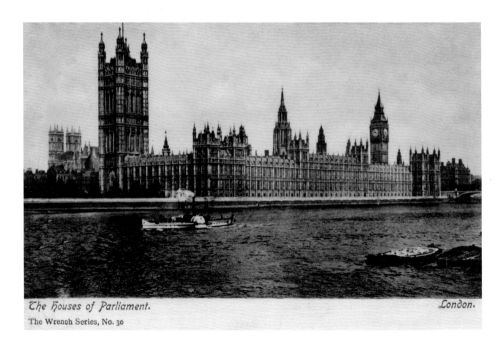

The Houses of Parliament.　　　　　　　　　　　　　　　　　*London.*
The Wrench Series, No. 30

It's now almost unique to see a paddle steamer pass in front of the Houses of Parliament, but in Edwardian times it was a common sight. The last paddle steamer to pass beyond here was the *Kingswear Castle* on one of her annual trips to Putney. The service is still kept alive by the popular Gravesend-based *Princess Pocahontas*, which operates day trips from Gravesend to London. Tide-permitting, it sometimes reaches as far as Putney.

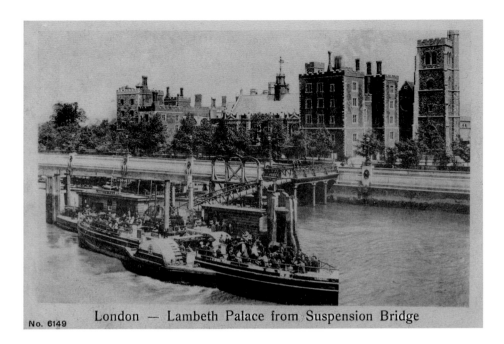

No. 6149 London — Lambeth Palace from Suspension Bridge

The *London* alongside Lambeth Pier, around 1905. These distinctive little paddle steamers acted as ferries on the Thames, and you can see from the open deck that facilities were somewhat basic. The obligatory hats and sunshades can be seen in abundance!

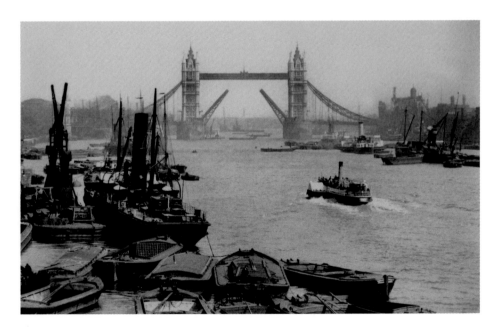

The Pool of London was at its busiest during the Edwardian period. Pleasure steamers from the General Steam Navigation and Belle Steamer fleets plied for trade to and from London. The Pool of London was used every day for mooring the paddle steamers waiting to ply the following day. In the centre of this image is one of the distinct London County Council paddle steamers travelling towards another London pier.

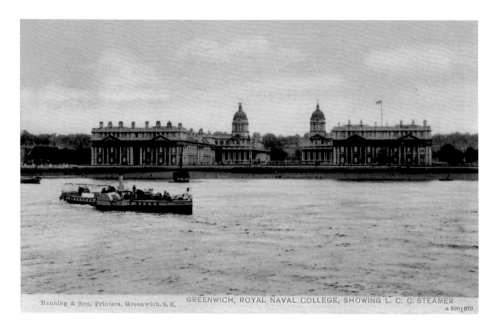

GREENWICH, ROYAL NAVAL COLLEGE, SHOWING L. C. C. STEAMER

Manning & Son, Printers, Greenwich, S. E.

a 8901878

Greenwich has never been viewed as a popular calling point for pleasure steamers. It was instead a calling point that was mainly used as a pick-up point after London. It witnessed a short flurry of service in Edwardian times when the LCC paddle steamers used it as a calling point. Today, Greenwich offers a spectacular vista for passengers to enjoy. Both *Waverley* and *Kingswear Castle* have made rare calls at Greenwich Pier.

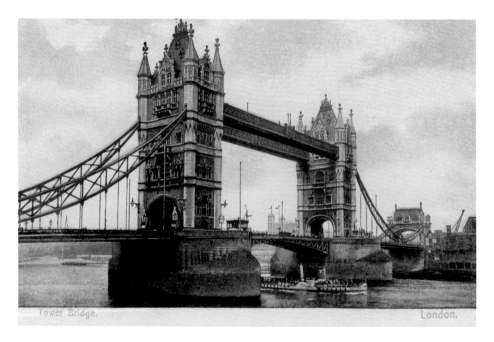

Tower Bridge. London.

A London County Council paddle steamer passing underneath Tower Bridge. Tower Bridge was at its busiest when this photograph was taken. It was abundantly clear that the design of the bridge was perfectly suited to its busy role.

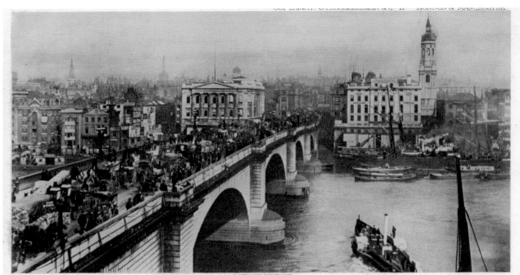

LONDON BRIDGE

It is always crowded like this, but this is nothing to the Crowds that are daily buying "Pat a Cake" Biscuits. Don't forget that offer of Peek Frean's. Have you tried any of the kinds yet? That Biscuit-box is worth having

A.W.E.

In the vicinity of the Tower of London, the Pool of London has always been a busy place for paddle steamers. After London Bridge, the number of bridges across the Thames increases and that, combined with the bends in the river and currents, made navigation by paddle steamer difficult. Tower Bridge was also close to the large passenger markets of the East End, and so provided more than ample numbers of passengers for the steamers.

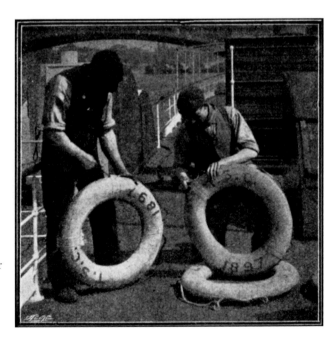

Overhauling lifebuoys on a LCC steamer. Safety has always been paramount on Thames paddle steamers, especially after the *Princess Alice* disaster of 1878. Regulations were further strengthened after the sinking of the *Titanic* in 1912.

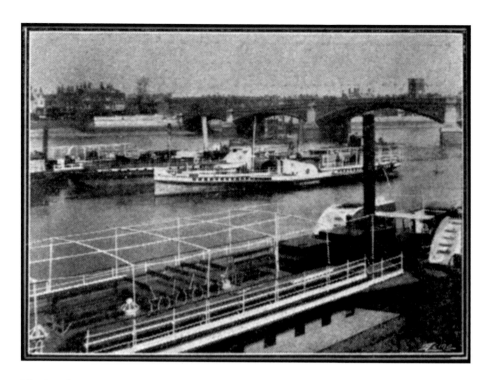

The London County Council fleet moored at Battersea Dock.

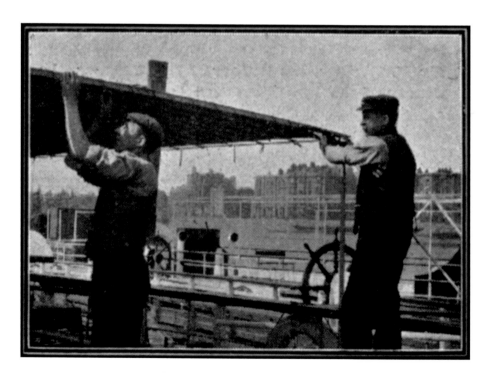

Fitting awnings to a LCC steamer. Awnings were needed on these steamers due to the lack of covered passenger accommodation.

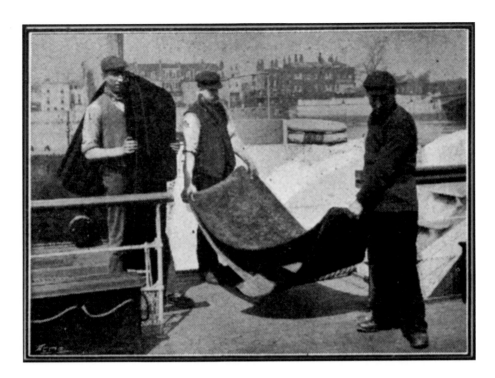

Taking carpets and seats onto the LCC steamers at the start of the season. There was always a flurry of activity at the start and finish of each season as the fleet was prepared for service.

Cleaning brass on a LCC steamer. This is a task that hasn't changed for well over one hundred years. The appearance of a paddle steamer has always been important. The abundance of brass, wood and painted areas meant that the crew were always busy preparing the steamer for its work.

Measuring seat lockers for cushions on a LCC steamer. Lifebelts were usually stored in these lockers, especially after the *Titanic* disaster. These small paddle steamers required a great deal of seating on deck to satisfy the needs of Edwardian folk who enjoyed the fresh air.

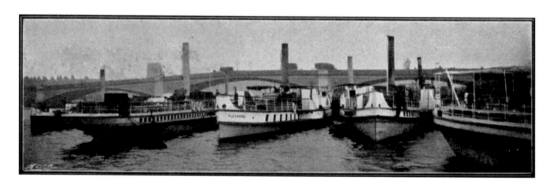

The assembled fleet of London County Council paddle steamers when they entered service during the Edwardian period.

Painting the hull of one of the LCC steamers, around 1905. Note the sponson deck that flared out at the middle of each steamer.

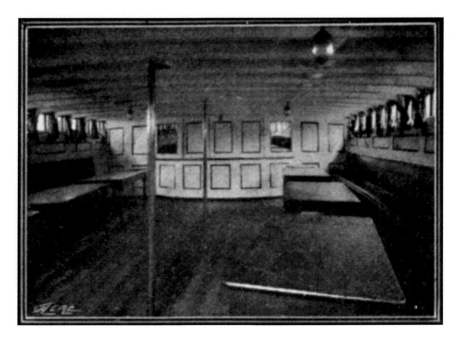

The aft saloon on the *Palm* of the LCC fleet. Passenger facilities were comfortable but basic. This saloon looks similar to those on the *Kingswear Castle* that was built in 1924.

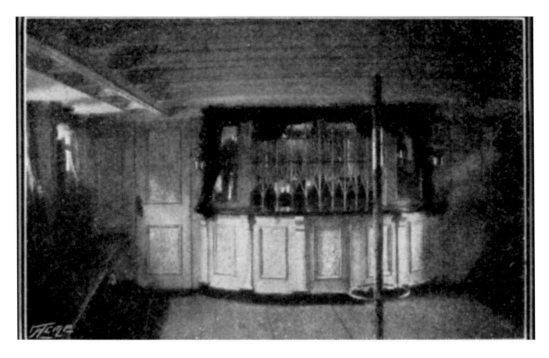

The refreshment bar aboard the *Boadicea*. Facilities were limited as passengers frequently embarked and disembarked at London's many piers.

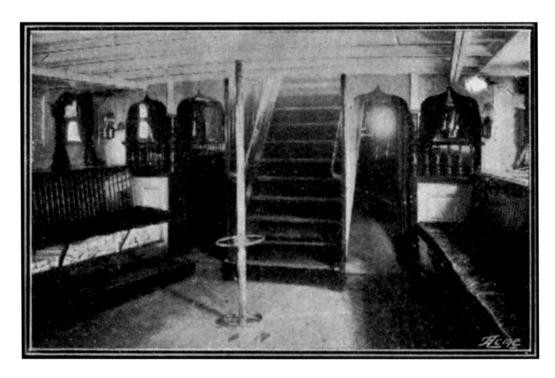

The aft cabin on the *Boadicea*. This cabin is a great deal smaller than those on the large coastal paddle steamers at the time.

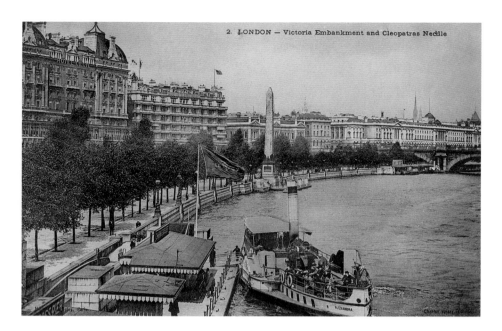

Alexandra embarking passengers at Charing Cross Pier. The paddle steamers that were used on the Thames upriver from the Pool of London were of a similar size and design. They were primarily ferries that took passengers on short trips either side of the river. Passengers also enjoyed trips as far as Hampton Court and Greenwich.

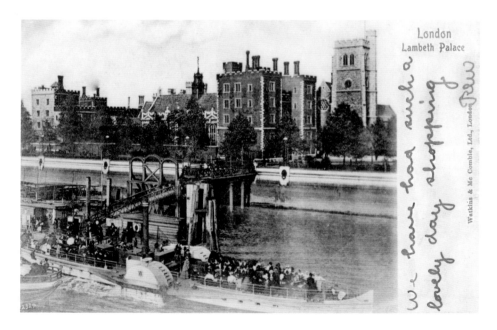

Lambeth Pier with an Edwardian paddle steamer alongside it. There has been a landing area at Lambeth since Roman times due to the need for a crossing point between Lambeth Palace and Westminster Palace for the Archbishop of Canterbury. Once a reliable means of steam propulsion was available, vessels such as the one in this image were able to provide services for pleasure.

31

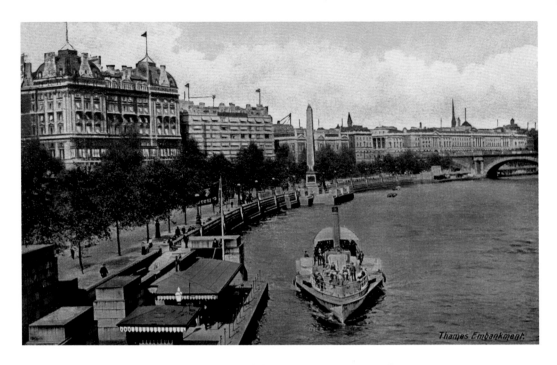

One of the London County Council paddle steamers arriving at Charing Cross Pier. Note the wide Thames Embankment that was constructed during the mid-Victorian period to accommodate the city's sewers, as well as the London Underground network. The memorial to Joseph Bazelgette, who masterminded the ambitious scheme, is placed at the top of the pier.

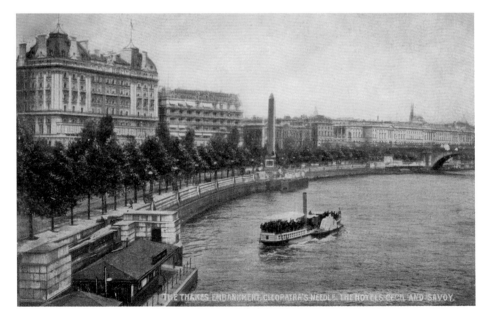

Paddle steamer departing from Charing Cross Pier in Edwardian times. The paddle steamer ferries at the time linked many of the mainline railway and underground stations.

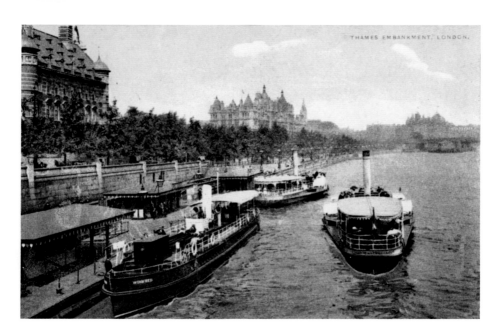

Winifred and two other paddle steamers arrive at a busy Westminster Pier.

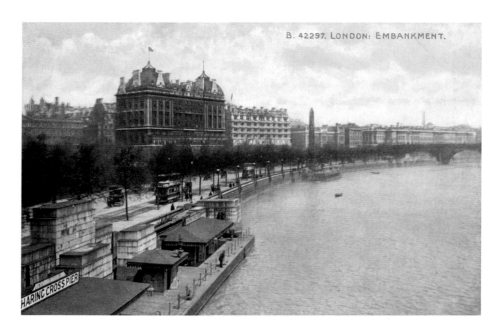

Charing Cross Pier had a very short link with paddle steamers. Charing Cross got its name from the old term for 'bend'. It was also once the site of a gallows and market place. The Victoria Embankment, on which the pier sits, cost nearly £2 million and was constructed between 1864 and 1870. Before the pier and Embankment were built, the area was occupied by muddy inlets and bays. Behind the pier lies Bazelgette's grand sewer system, as well as the Underground line. 650,000 cubic feet of granite were used in the works, as well as 80,000 cubic yards of brickwork; 140,000 cubic yards of concrete; 500,000 cubic feet of timber and 125,000 feet of York paving.

LONDON - HOUSES OF PARLIAMENT.

Two London County Council paddle steamers speed towards Westminster Pier around 1905. Services ceased a few years later.

330 HOUSES OF PARLIAMENT FROM RIVER, LONDON

Despite the Thames being central to the life of London, the river did not see widespread use for commuter services until the twenty-first century with the Clipper river service being fully exploited. The service provides fast links to the many new areas of commerce such as Canary Wharf from luxury apartments at places such as Woolwich. This is in stark contrast to the small and sedate services provided by the LCC paddle steamers in Edwardian times.

One of the London County Council paddle steamers passing the Houses of Parliament during Edwardian times.

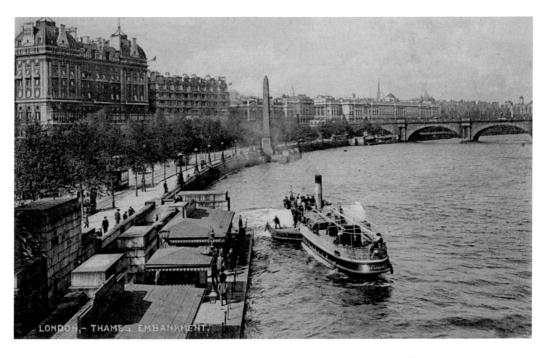

The paddle steamer *Pepys* arriving at Charing Cross Pier. Note the deckhand securing the rope to the pier.

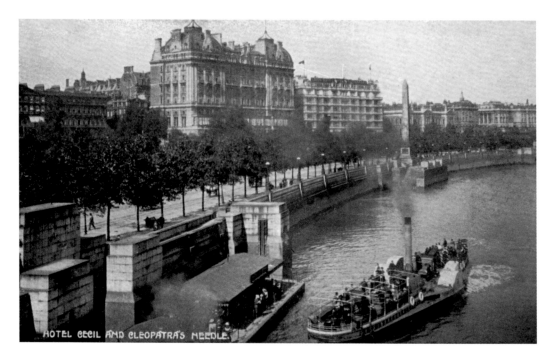

HOTEL CECIL AND CLEOPATRAS NEEDLE.

The distinctive-looking London County Council fleet of thirty paddle steamers was built in four shipyards around the United Kingdon. The almost-new fleet saw more service around the world after the quick collapse of Thames operations. They found new roles in Germany, Rouen, Belgium, Lake Lugano, Dundee, Lake Lucerne, Portsmouth and Loch Lomond.

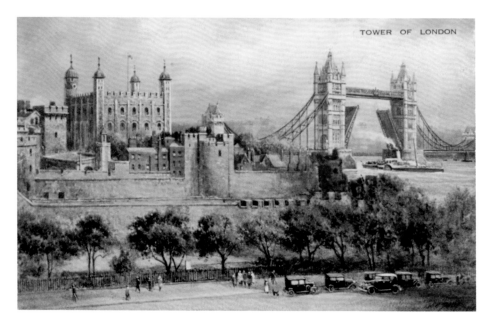

TOWER OF LONDON

The Tower of London is the site where London first grew and developed as a port. The White Tower was built by William the Conqueror. Since the early nineteenth century, paddle steamers have plied from nearby piers to the resorts of Kent and Essex.

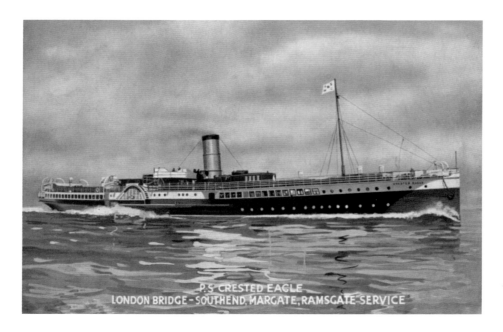

P.S CRESTED EAGLE
LONDON BRIDGE - SOUTHEND, MARGATE, RAMSGATE SERVICE

Crested Eagle was built by the J. Samuel White shipyard on the Isle of Wight. Her Thames career encompassed an era of significant change when more modern turbine vessels were introduced at the same time that Tower Pier was being built. She also had one of the shortest careers of a Thames pleasure steamer. It lasted for less than twenty years before she was sunk during the Second World War.

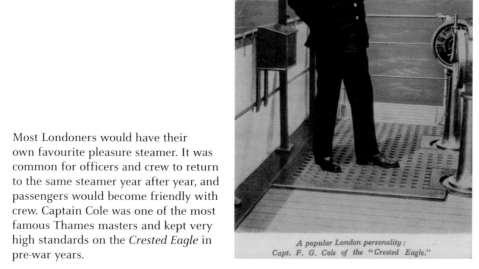

Most Londoners would have their own favourite pleasure steamer. It was common for officers and crew to return to the same steamer year after year, and passengers would become friendly with crew. Captain Cole was one of the most famous Thames masters and kept very high standards on the *Crested Eagle* in pre-war years.

A popular London personality :
Capt. F. G. Cole of the "Crested Eagle."

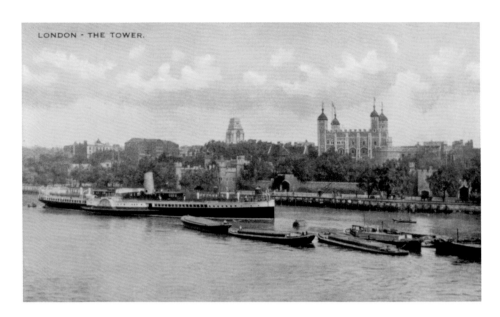

Crested Eagle during the inter-war years. She was oil-fired and provided the East Anglian coast service between London, Southend, Clacton and Felixstowe after 1932. Her deck house, found in front of her funnel, was originally made of wood but changed to a more modern white design in 1939, shortly before she was sunk.

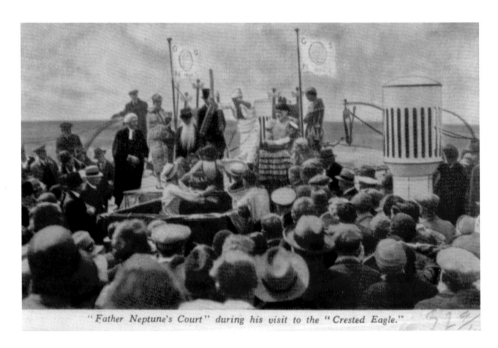

" Father Neptune's Court" during his visit to the " Crested Eagle."

'Father Neptune's Court' aboard the *Royal Eagle* during the inter-war years. In the days before iPods and mobile phones, Londoners needed some entertainment during the often long cruise to the coast. Singing competitions were often organised, along with playing games of deck quoits. On some cruises the ceremony, such as the one shown on this card, was held and passengers were initiated and got wet at the same time!

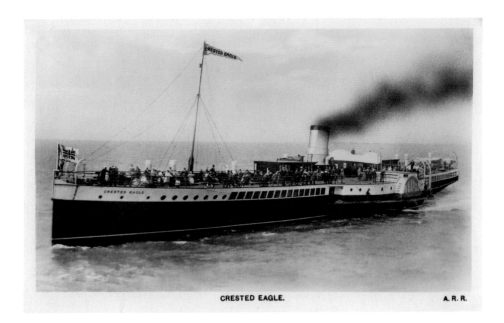

CRESTED EAGLE. A. R. R.

Crested Eagle was one of the most distinctive paddle steamers that London ever saw. She had a traditional open bridge that gave the unfortunate master little protection in bad weather. Passengers likewise had little protection from the elements, as can be seen in this image.

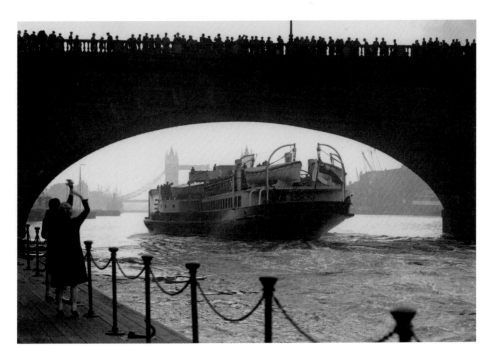

A spectacular view of the *Crested Eagle* passing under London Bridge in the 1920s. It shows her collapsible funnel almost flat, allowing her to pass under the bridge in the days before Tower Pier was built. Note the public standing on the bridge above to view the strange sight of a paddle steamer with no funnel.

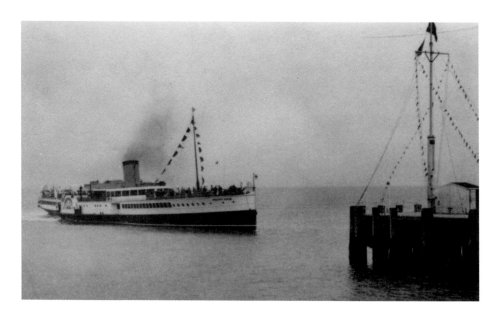

Crested Eagle approaching Clacton Pier on the first day of her season in 1939. That was to be her final season in peacetime operation; she was lost at Dunkirk in a horrific fire after she was bombed and her fuel ignited. Many lives were lost in this tragedy. Note the large white observation lounge that she had for just the 1939 season.

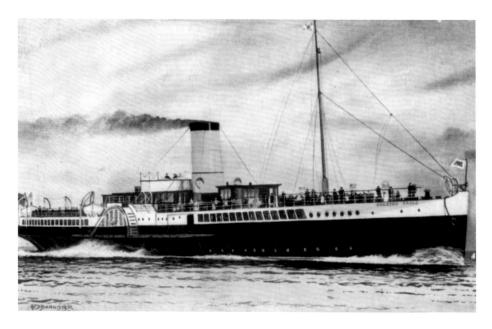

Crested Eagle was one of the most distinctive of London's pleasure steamers. Her short telescopic funnel enabled her to pass underneath London Bridge. Shortly after she entered service, London's Tower Pier was built and she was then able to land passengers there. This of course made her telescopic funnel redundant. The small number of deck houses contrasts with the vast deck houses and passenger accommodation aboard the *Royal Eagle* a decade later.

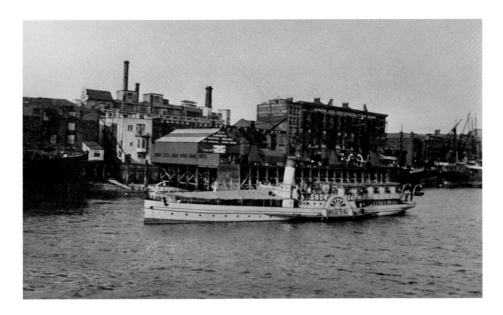

London has seen a number of short-lived and novel attempts to operate paddle steamers. The Cosens Company of Weymouth were well-known for their old and run-down paddle steamers that had long lives. The *Alexandra* was bought to the Thames in 1932 to operate as the *Showboat*. She offered cruises with entertainers aboard. This service had a very short life.

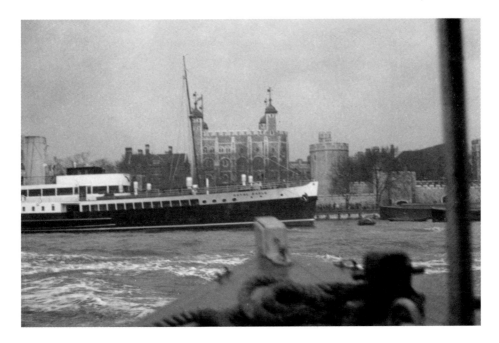

Royal Eagle with the Tower of London in the background around 1948. She was known as 'London's Luxury Liner', and was around twice the size of her competitors. The sheer scale and luxury of her many saloons, bars and lounges was breathtaking. She was built for the popular service from London to Margate and Ramsgate.

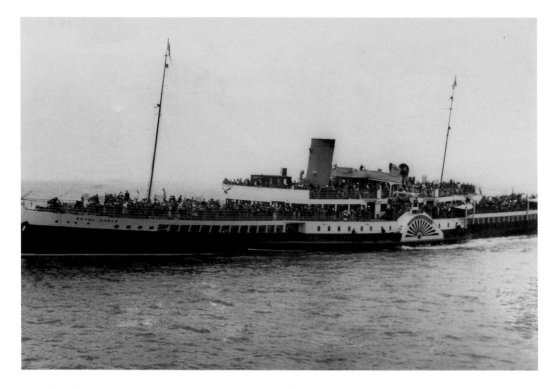

Royal Eagle at sea. At 1,590 tons, *Royal Eagle* was about twice the size of other paddle steamers built during the inter-war years. Her catering facilities were equally impressive and she could boast such luxuries as an ice cream bar and soda fountain. She spent just thirteen summers taking passengers up and down the Thames from London. It was sad that the *Royal Eagle* had such a short career when she was such an impressive and unique vessel.

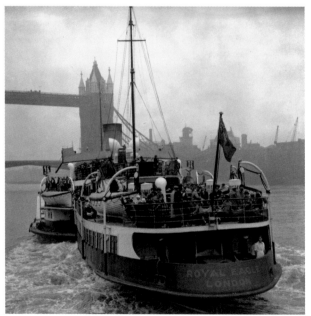

Royal Eagle having just departed from Tower Pier London on her way to the coast. You can appreciate the immense passenger accommodation in this view. The stern depicts the deck crew having just helped to cast-off the steamer. A cook is also relaxing before the inevitable onslaught in the adjacent dining saloon. The crew were kept incredible busy during the summer months. They tended to go deep sea or to work in London hotels during the winter.

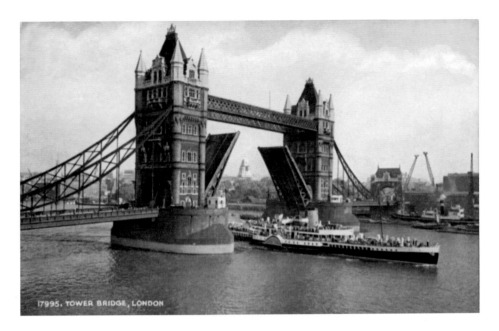

17995. TOWER BRIDGE, LONDON

Royal Eagle at Tower Bridge. She sometimes travelled away from London and, in May 1936, she steamed to Southampton to witness the departure of the Cunard liner *Queen Mary* on her maiden voyage. After withdrawal, it was rumoured that *Royal Eagle* might see service elsewhere in the United Kingdom. Her huge size meant that this was never possible. If she was too large for London, she would be even harder to operate elsewhere.

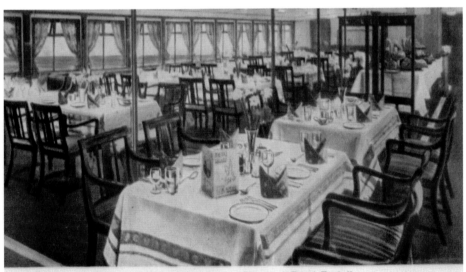

View of half the Main Dining Saloon: " Royal Eagle."

The atmospheric dining saloon of the *Royal Eagle*. Here, 322 diners could be accommodated at each sitting. Silver service was provided by liveried stewards. Breakfast, luncheon, tea and dinner were served. Passengers bought a ticket for their meal that was served at a specific time. No dawdling was allowed and passengers were quickly moved on to allow the next diners to enter.

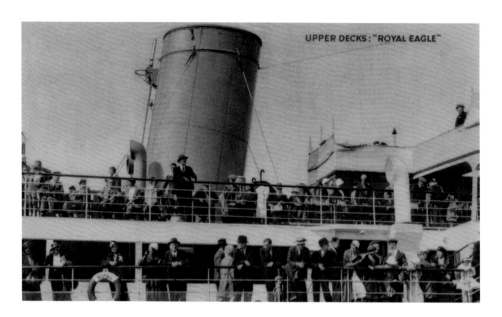

Royal Eagle had wonderful wide decks for relaxing on and for admiring the fine views at London. Passengers were always divided by class, and Eagle Steamers charged extra for deckchairs and any other optional extra. Private saloons were also offered. These could accommodate between fourteen and twenty-two people and cost £1. Lunches could be provided in these saloons for three shillings and sixpence a head.

See the Wonders of the Lower Thames
"EAGLE STEAMERS"

DAILY (except Fridays) Whitsun to mid-Sept. from TOWER OF LONDON PIER through the commercial activity of the Thames to the coastal resorts of SOUTHEND, MARGATE, CLACTON etc.

SPECIAL CHEAP DAY RETURN FARES MID-WEEK

G.S.N.
Co. Ltd.
15 Trinity Square,
London,
E.C. 3.
Tel.
Royal 3200

Advertisement for the *Royal Eagle's* cruises from London during the 1930s. Just a few years after she entered service, her design was becoming rather old-fashioned when Captain Shippick revolutionised London's pleasure steamers with the new-look motor vessels.

Royal Eagle was one of the most distinctive of London's paddle steamers. Her futuristic observation lounge was a reminder of the Art Deco age. She didn't have the simple deck houses of her predecessors but the lavishness of her deck lounges, reflecting the 1930s motor ships, looked towards the future. This view shows the *Royal Sovereign* alongside Tower Pier. In this view, *Royal Eagle's* career was almost over.

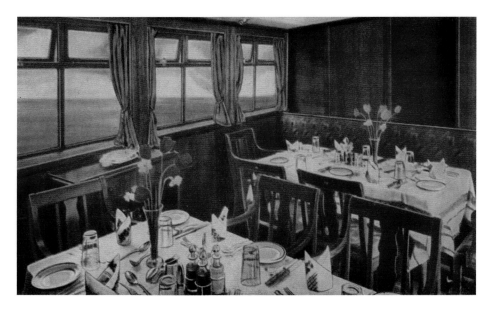

Despite the inter-war years being years of great change, a day out to the seaside by pleasure steamer was one of the great highlights of each summer. The mid-1930s saw the 'Holidays with Pay Act' come into force, allowing people to have more time at the coast by steamer. Some lucky passengers were able to use the 'Mahogany' dining saloon aboard the *Royal Eagle*.

The Tower Bridge and the Senior Head Watchman of the Bridge

Tower Bridge has been synonymous with London's pleasure steamers since it opened in 1894; it would be hard to imagine a day trip to or from London without passing under the famous bridge. It was designed by Sir Horace Jones and Sir J. Wolfe Barry. The two cantilever arms can be elevated vertically. This is only done for royal visits, whereas other lifts only raise to around 40 degrees. These days, the whole procedure is more or less automatic, unlike the old days when a large number of staff were employed.

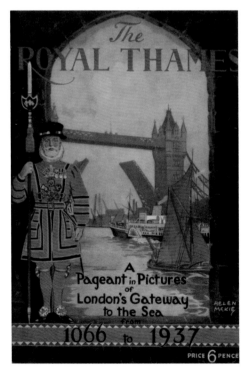

The Royal Thames

A Pageant in Pictures
of
London's Gateway
to the Sea
from
1066 to 1937

PRICE 6 PENCE

Cover for the Eagle Steamer guide 'The Royal Thames', published in the coronation year of 1937. It features the *Royal Eagle* at the centre. General Steam Navigation produced a number of high-quality souvenir brochures for their passengers. They included a guide to sights on the way to the sea as well as advertisements for attractions and hotels at their destination resort.

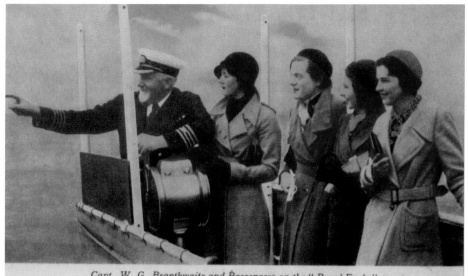

Capt. W. G. Branthwaite and Passengers on the " Royal Eagle."

Captain Bill Branthwaite was known to generations of Londoners for his jovial and friendly personality towards his passengers. He was master of the *Golden Eagle* from 1923 to 1931 and then took command of the General Steam Navigation's flagship pleasure steamer, the *Royal Eagle*, in 1932.

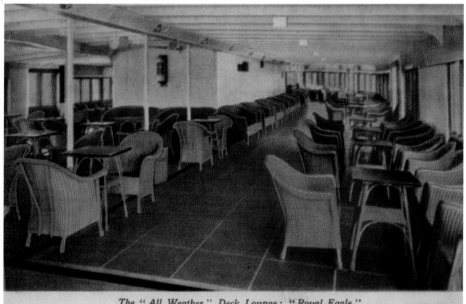

The " All Weather " Deck Lounge: "Royal Eagle."

When the *Royal Eagle* entered Thames service in 1932, Londoners were astonished by the fine modern and luxurious passenger accommodation. Gone were the days when passengers had to brave the elements. Now, passengers could relax in huge lounges such as this. Dancing was also allowed here, with music being broadcast over the tannoy. Eagle Steamers of course charged for the use of this and other exclusive areas of the steamer.

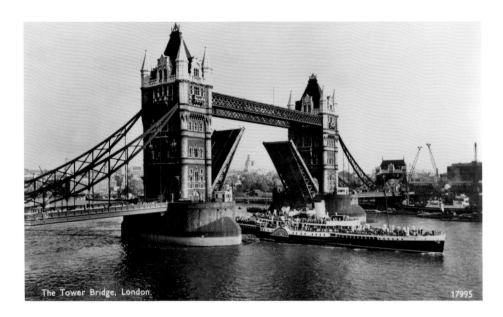

The Tower Bridge, London. 17995

Royal Eagle at Tower Bridge. *Royal Eagle* regularly took London passengers to Southend Pier. The pier welcomed over 5,750,000 visitors a year during its post-war heyday of 1949–50. Many of these passengers arrived and departed by paddle steamer at the 326-foot-long Prince George landing facility.

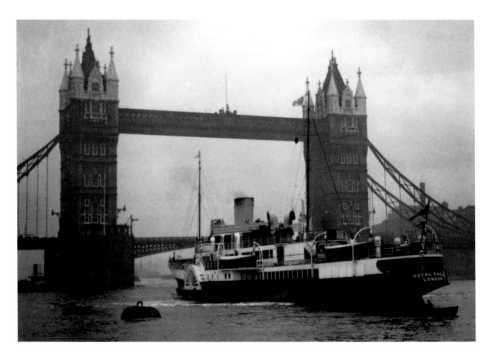

Royal Eagle could carry around 1,900 passengers and required a crew of around one hundred, including seventy in the catering department. This department was always busy and the restaurant could seat 322 passengers at a time, where they enjoyed meals of lobster, steak, fish and roast beef.

A corner of the Deck Lounge: "Royal Eagle."

The *Royal Eagle* was a revolution on the London river when she entered service in 1932. Her open and spacious passenger accommodation was a stark contrast to the stuffy interiors of the Victorian paddle steamers. This view of a deck lounge shows the linoleum and Lloyd Loom chairs that were synonymous with the Art Deco age.

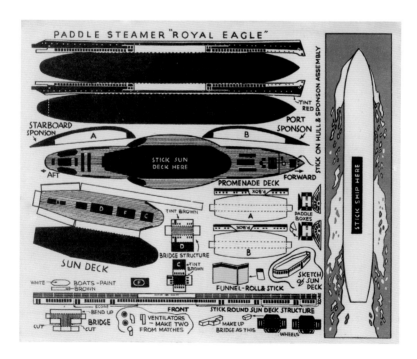

Most Londoners that had a cruise on a pleasure steamer purchased a small souvenir on board to remember their day by. This card model kit of the *Royal Eagle* was a popular souvenir among young boys. The Eagle Steamers sold a variety of souvenirs aboard the famous pleasure steamers. These included silk handkerchiefs, sailor dolls, caddy spoons and match cases.

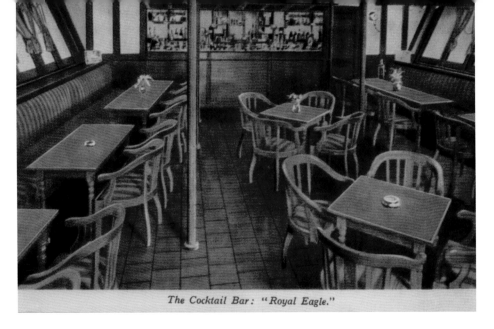

The Cocktail Bar: "Royal Eagle."

A somewhat strange olde worlde interior aboard the *Royal Eagle*. This half-timber interior was used on the pre-war *Queen of the Channel*, which seems rather odd considering the ultra modern look of the vessels. Fathers would often say that they 'were going to see the engines'. This meant that they were going to have a drink as the bars were usually located low on the steamer, around the water line. Londoners were famed for their love of drink on the pleasure steamers. Many would say what a grand day they'd had, despite spending all of it in the bar!

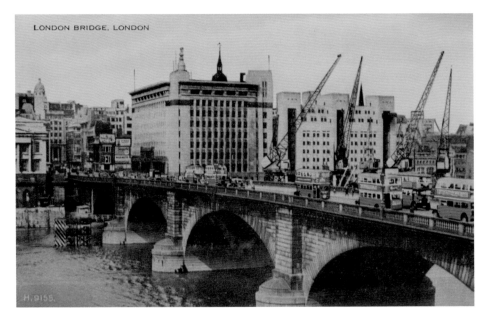

LONDON BRIDGE, LONDON

London Bridge was built in 1831 with Aberdeen granite and was widened in 1904. It had five arches, which was a stark contrast to the nineteen arches on the original, and most famous, bridge that had a street built upon it.

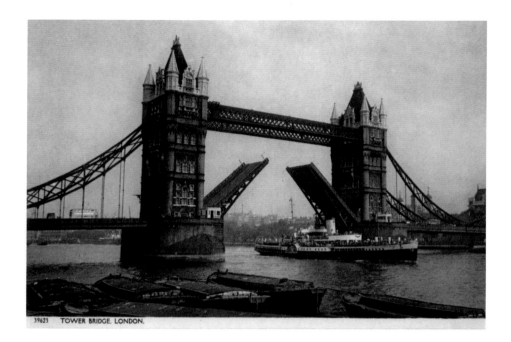

39623 TOWER BRIDGE, LONDON.

Royal Eagle was built at the famous Cammell-Laird yard at Birkenhead. She was launched with a bottle of whiskey and took up London service at the commencement of the 1932 season. By this time, more modern and efficient motor ships were being introduced, so it was somewhat strange that GSNC introduced a paddle steamer.

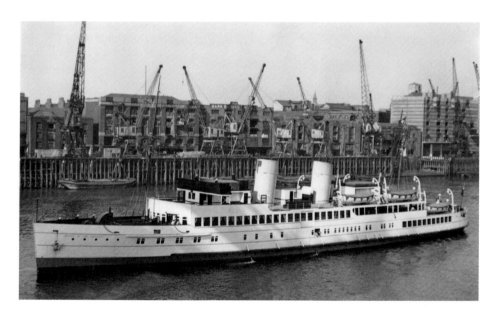

The arrival of the Denny-built motor vessels in the mid-1930s revolutionised services on the Thames and Medway, introducing London passengers to a new style of pleasure steamer travel. The new, pre-war *Queen of the Channel* is shown here. On her trials she attained a speed of 21.7 knots, which was a record for her type. She operated the London to Gravesend, Tilbury, Southend, Margate and France route.

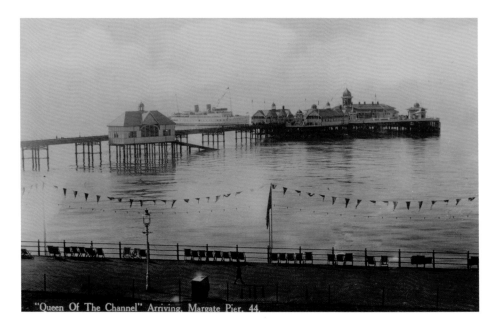

"Queen Of The Channel" Arriving, Margate Pier. 44.

The pre-war *Queen of the Channel* arriving at Margate Jetty before the Second World War. She was built by Denny of Dumbarton in 1935. She was smaller than the *Royal Eagle* and was universally admired by ship enthusiasts due to her magnificent design and build. Her front funnel was a dummy.

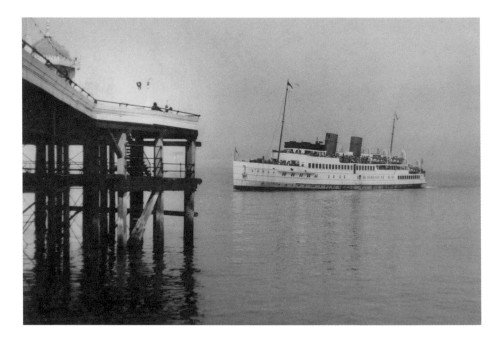

By the mid-1930s, Londoners were able to travel from the capital city as well as places such as Margate, shown here, to Ostend aboard the new luxury vessels the *Royal Sovereign* and the *Queen of the Channel*. The availability of affordable trips to the Continent was a great enticement for passengers in those pre-war years. A weekend return cost just 12s 6d.

A splendid-looking *Royal Daffodil* ready to embark upon her maiden voyage from London Tower pier on 27 May 1939. Just look at that pristine paintwork! Just three months later, the *Royal Daffodil* was plunged into the darkness of the Second World War – the men that had once gone on her for a day at Southend were pleased to see her as she rescued them at Dunkirk.

Royal Eagle moored close to the Tower of London in the late 1940s. *Royal Eagle* was the first London pleasure steamer to take up peacetime duties in 1946. Initially, demobbed Londoners flocked aboard the vessels to recreate their pre-war happy days at the seaside. Within a few years, *Royal Eagle* and the rest of the fleet were clearly too large for post-war trade. *Royal Eagle* entered the 1950s by being laid up and later scrapped. This fine London pleasure steamer had seen fewer than twenty years in service.

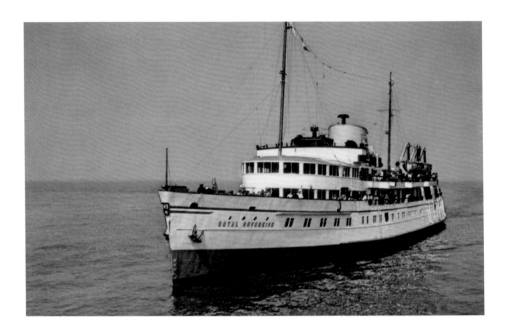

Royal Sovereign had her maiden voyage on 24 July 1948 when she sailed from Tower Pier to Ramsgate. She was very similar to the other Thames motor vessels. She had a covered observation lounge on the sun deck as well as a spacious lounge on the promenade deck. On the main deck were two dining rooms capable of seating 140 and 96 diners.

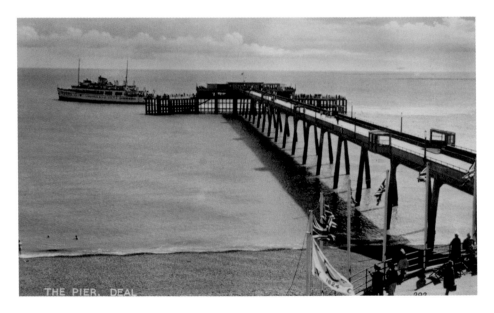

Up to the mid-1960s, there was a highly-developed pleasure steamer service to the Continent from London and the Kentish seaside resorts. Vessels such as the *Queen of the Channel* would make regular summer crossings to land passengers from places such as Deal. *Balmoral* was the last traditional large pleasure steamer to cross the English Channel to Boulogne in 1993. A few years earlier, *Waverley* took passengers to the coast of France for the Dunkirk commemorations.

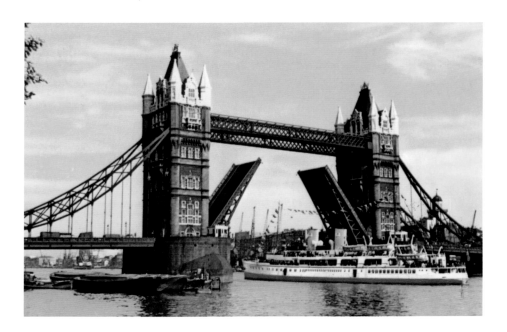

Royal Daffodil became London's favourite pleasure steamer and is synonymous with Thames pleasure steamer services. Her theme tune was the 'Post Horn Gallop' and it was played as she passed the raised bascules of Tower Bridge. She never sailed on Fridays. This was due to superstition, as the Victorian paddle steamer *Princess Alice* perished on that day of the week.

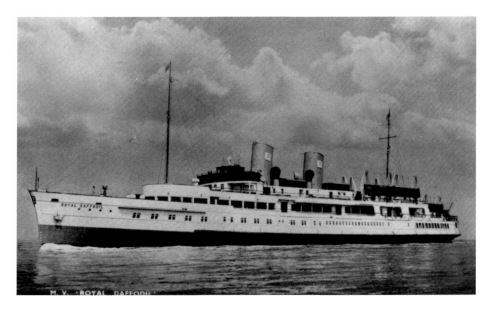

If you mention the pleasure steamers that operated on the Thames from London in post-war years, most people will immediately remember the *Royal Daffodil* with great affection. When she entered service, she operated from London Tower Pier to the continent. During the 1960s, she operated popular music cruises that included music from artists such as Kenny Ball, Gene Vincent and Jerry Lee Lewis.

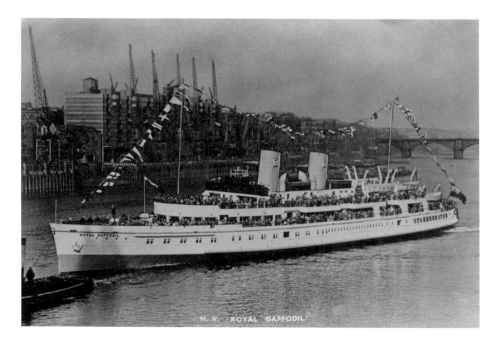

The huge size of the *Royal Daffodil* can be appreciated in this view as she departs the Pool of London on a cruise. Note the old London Bridge in the background and the Thames-side cranes that have now disappeared. The *Daffodil* was 313 feet in length, 54 feet wide and her engines could provide a speed of 21 knots. She could carry up to 2,063 passengers.

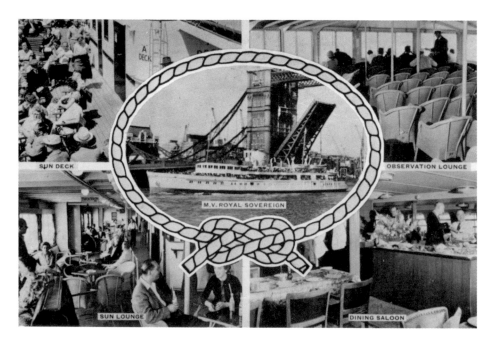

Royal Sovereign provided excellent facilities for her passengers in the post-war years. Unfortunately, her ample facilities were too large to be economic during the 1960s and there was little that GSN could do to stop the decline in usage.

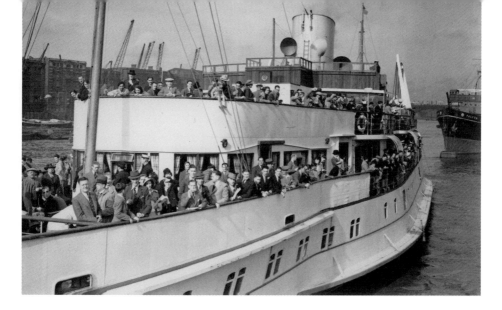

Queen of the Channel arriving at London Tower Pier. These sleek-white vessels provided amazing comfort and luxury for Londoners in the post-war years. They combined plenty of open-deck space for good weather, as well as a huge amount of more lucrative covered accommodation for rainy days. Note the flaring of the hull to increase the size of the passenger accommodation. It made them look more like paddle steamers. The motor ships had the potential to make vast amounts of money for General Steam Navigation, but the post-war market was simply not large enough to use them to their full potential.

When the *Royal Daffodil,* shown here, was withdrawn at the end of the 1966 season, there was calm acceptance that it was the end of an era. Despite her going to the scrapyard, Londoners felt that there was still hope that regular services would survive. They were encouraged by the short-lived but brave attempts at preservation with steamers such as the *Queen of the South.*

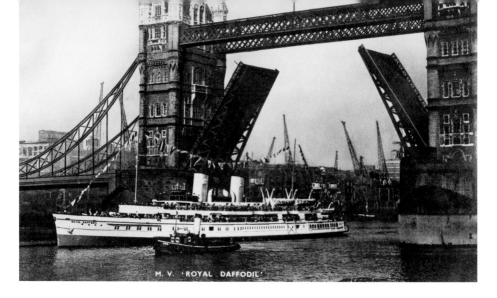

M.V. 'ROYAL DAFFODIL'

Royal Daffodil was built by the distinguished Denny yard at Dumbarton, who had an enviable reputation for building high-class pleasure steamers. She was powered by two twelve-cylinder Sulzer diesel-engines. Her passenger carrying capacity was very high. This was of course good in the buoyant pre-war days, but the quickly shrinking market of the post-war years made her uneconomic very quickly. She was the first of the London pleasure steamers to go.

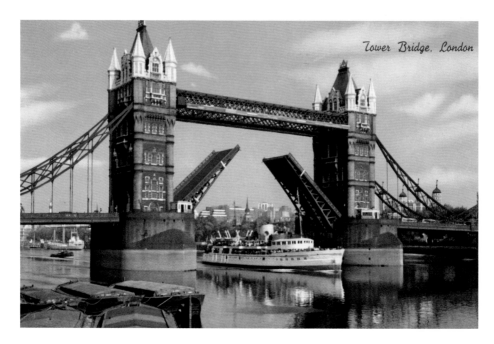

Tower Bridge, London

Royal Sovereign was the second motor vessel to bear the name. She was built by the famed Denny of Dumbarton yard and could operate at 21 knots, entering service in 1948. She became the longest-lived of the motor-ship fleet and survived for several decades after withdrawal, as she was converted into a ferry in Italy. None of her London passengers would have recognised her when she was finally withdrawn.

London always featured prominently on guides produced by the General Steam Navigation Company. The River Thames, with its endless supply of historical sights and facts, provided more than ample amusement for passengers who admired the history of the London River while relaxing in a deckchair reading one of these guides.

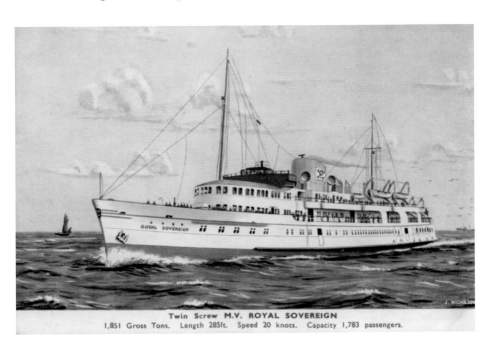

Twin Screw M.V. ROYAL SOVEREIGN
1,851 Gross Tons. Length 285ft. Speed 20 knots. Capacity 1,783 passengers.

The *Royal Sovereign* was a beautiful ship and one of the greatest products of the Denny yard. Just compare this view of her against a Victorian paddle steamer and appreciate the vastly superior passenger accommodation aboard the *Royal Sovereign*.

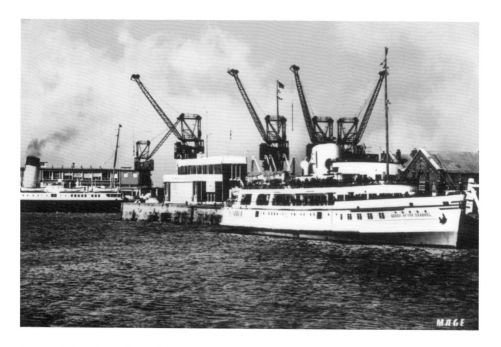

Queen of the Channel at Calais. France was a popular destination for Londoners from the 1930s onwards. During the 1960s, GSN attempted to reverse the steep decline in trade. They offered Londoners the chance to visit places such as Barcelona with onward travel by coach from the French ports that they served.

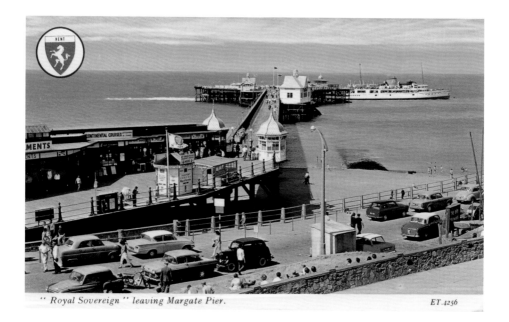

" Royal Sovereign " leaving Margate Pier. ET.4256

Royal Sovereign departing from Margate Jetty in the mid-1960s. It took around five hours to reach Margate from London by pleasure steamer. By motor car it was a great deal less, which meant that many chose to take the car in the 1950s and 1960s. This is evident in this view.

Margate was a well-loved destination for Londoners. The *Royal Sovereign* is seen departing from the jetty in this view. There was usually enough time to go ashore for an ice cream or to play on the beach. Other passengers would stay aboard, or join for a short trip round the Kent coastline. The Dreamland amusement park was a favourite haunt of General Steam Navigation passengers.

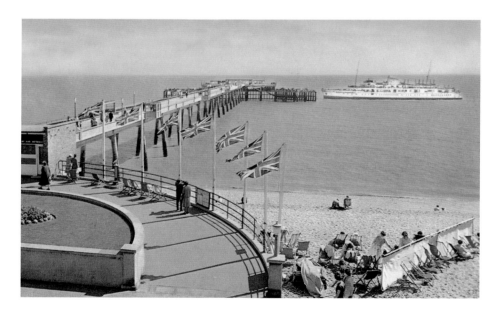

Queen of the Channel often called at Deal Pier to take passengers to France. The pier was built in the late 1950s. Its modern design and fine landing facilities were only used for a few years until services ceased in the mid-1960s. Londoners could travel to France for the day or weekend yet, despite attempts to enliven services in the 1960s with gimmicks such as jazz cruises, the service couldn't compete with the cross-Channel ferries.

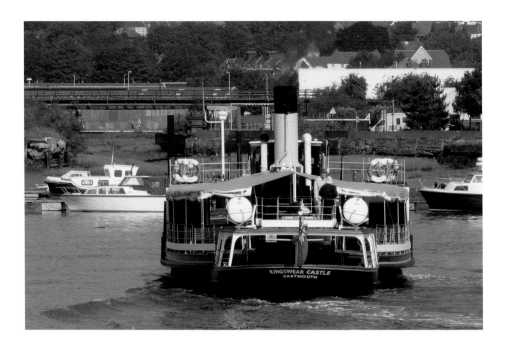

By around 1970, the tradition of coastal cruising from places like London to the seaside resorts of Kent and Essex had more or less ceased. With the withdrawal of the UK paddle steamer fleet, it was left to a few survivors such as the *Kingswear Castle,* shown here, to face lengthy and costly restoration projects to enable them to enter service again. The 1970s was therefore a decade of slumber for most UK and London pleasure steamers.

Royal Daffodil (left) at Boulogne. Eagle Steamers provided popular trips to places such as Boulogne and Calais. They gave Londoners the chance to discover the then unfamiliar food and language of France. Many though, remember the trips for other reasons as they experienced horrendous seasickness in the English Channel!

Queen of the Channel at Calais in post-war years. She entered service in 1949 and could carry up to 1,500 passengers at a speed of around 19 knots. After initial service from Ramsgate, she operated the London Tower Pier to Clacton service, replacing the hugely uneconomic *Royal Eagle*. She later operated from Ramsgate and Deal to France. After withdrawal, she was sold for further service in the Mediterranean and renamed as *Oia*.

Royal Daffodil at Boulogne in post-war years. After the war, landing trips to France weren't allowed but by the mid-1950s they were re-introduced. They were synonymous with Eagle Steamers during the 1950s and 1960s. *Royal Daffodil* was the first of the large London motor ships to be withdrawn. Her departure from the Thames was filmed by the BBC. Most passengers calmly accepted her departure as they thought that there was still hope for one of the other vessels to survive with a smaller fleet.

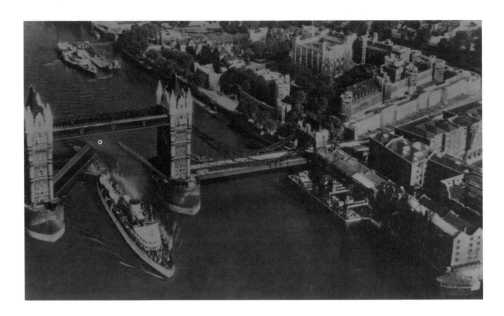

Royal Sovereign passing under Tower Bridge with the *Royal Eagle* alongside Tower Pier. This photograph was taken during the late 1940s when Thames services experienced a boom in services. *Royal Sovereign* had just entered service and the *Royal Eagle,* despite being less than two decades old, was facing withdrawal soon after this photo was taken.

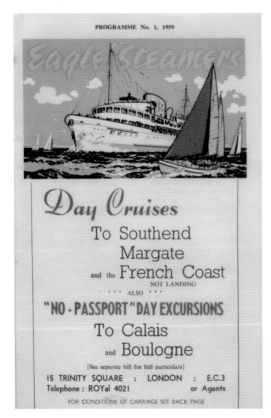

Eagle Steamers produced some excellent programmes and handbills for their London customers. This example from 1959 advertises trips to Margate from Tower Pier at 21 shillings, and trips to France for 25 shillings departing from Gravesend. The newly opened Deal Pier was used in this cruise.

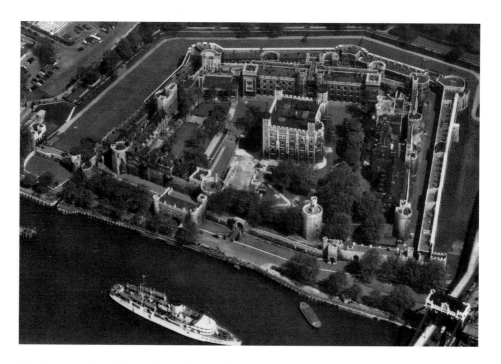

The famous *Royal Sovereign* in front of the Tower of London. The Tower goes back to the time of William the Conqueror. Since the advent of the passenger pleasure steamer it has witnessed many historical events. Hitler's Deputy, Rudolf Hess, was imprisoned there during the Second World War. Two of the last prisoners to be held were Ronnie and Reggie Kray, who were locked up for going absent without leave during their National Service.

Royal Sovereign was an impressive 288 feet in length and could convey 1783 passengers at 19 knots to Southend and Margate. She was launched on 7 May 1948 and was delivered to GSNC on 15 July 1948.

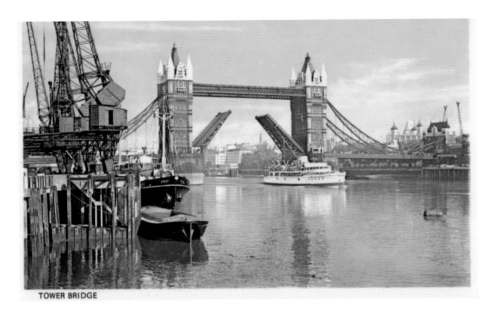

TOWER BRIDGE

Royal Sovereign departing from London in the late-1950s. The skyline above and beyond the *Royal Sovereign* and Tower Bridge has changed dramatically since that time. Buildings such as the Gherkin and the 'Cheese Grater' skyscraper (Leadenhall Building) have been built in recent years. They were joined in 2013 by the Shard, found on the south bank of the Thames. The Shard provides views of passing pleasure steamers from a height of 306 metres.

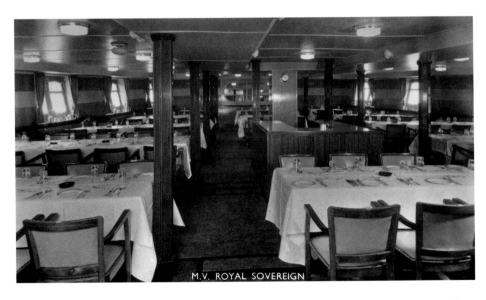

M.V. ROYAL SOVEREIGN

The forward dining saloon of the post-war *Royal Sovereign*. The post-war Eagle Steamer fleet were famed for their legendary dining facilities. Diners ate their meals to a strict regime as such a large number of people had to be fed each day. Meals were timed and efficient waiters persuaded diners to move on, ready for their next clients. The dining saloons always looked wonderful with crisp linen tablecloths and silver crested silverware. These teapots, coffee pots and sugar basins can be seen lining the windowsills adjacent to each table.

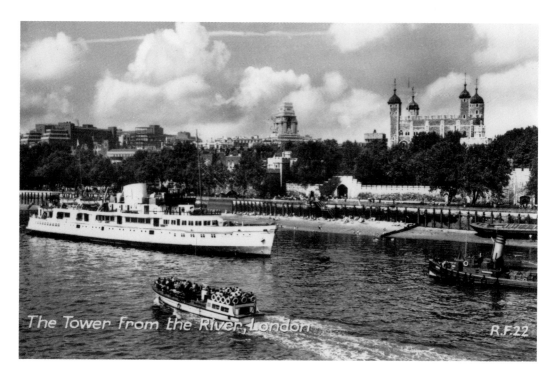

Queen of the Channel in post-war years. She looked very similar to the *Royal Sovereign* but can be easily identified by the open deck above the forward observation lounge that shows a glass screen.

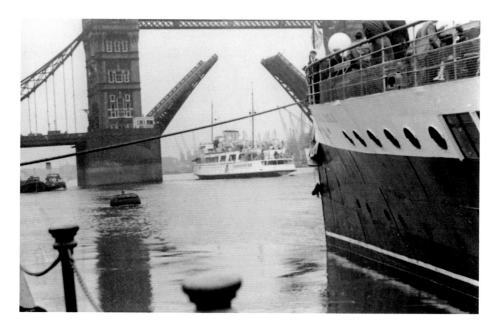

Passengers can be seen aboard the *Royal Eagle* as one of the motor vessels departs from the capital. *Royal Eagle* and the motor ships were built at almost the same time yet they were miles apart in design and looks.

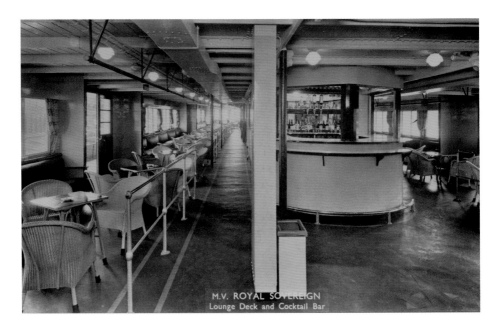

This view shows the vast cocktail bar and lounge deck aboard the post-war *Royal Sovereign*. The three GSNC motor ships were stunning vessels and it's clear from this image why they were so popular with Londoners – their spacious covered passenger accommodation provided superb facilities in which to relax on the way to the seaside.

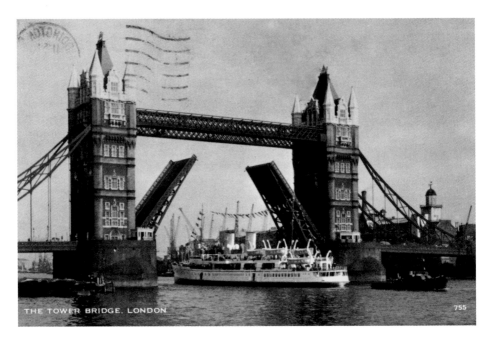

Royal Daffodil departing from London for a cruise. Passengers could purchase a postcard like this on the steamer. It was often given a special frank by a rubber stamp. The GSNC steamers never had large souvenir shops. Instead, passengers usually purchased a guide from a crew member who wandered around the deck.

The *Royal Daffodil* in dry dock towards the end of her career on the River Thames. The three General Steam Navigation motor ships spent around half of each year tied up at places such as Deptford or in dry dock. While they only worked from Easter to October, the rest of the year was filled with painting, repairs and upgrading passenger facilities. All three motor ships were famous for their spotless appearance.

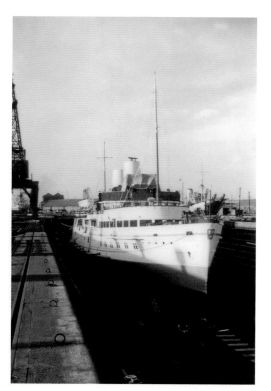

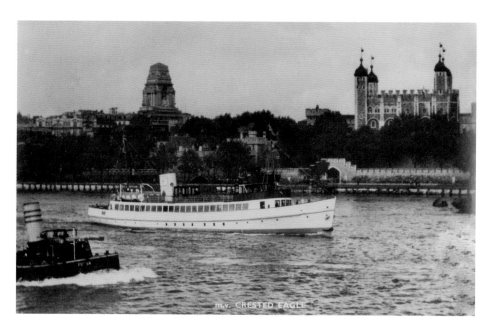

The motor vessel *Crested Eagle* was one of the smallest vessels of the Eagle Steamer fleet. She undertook cruises from places such as Gravesend and Ramsgate, but is perhaps best known to Londoners for the London Docks cruises that she operated from Tower Pier. Note that there are no high-rise buildings in this view. This changed after the 1960s.

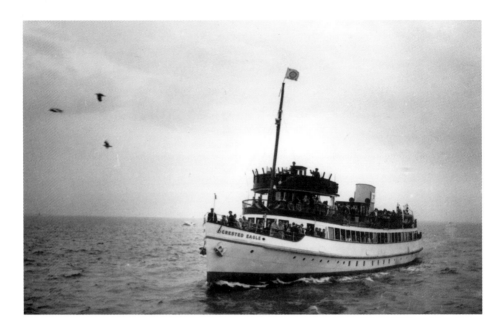

London Docks cruises were hugely popular with passengers up to the decline of the docks in the early 1960s. Passengers were able to see a huge amount of activity as vessels arrived and departed. Today, the Port of London is still very busy – passengers aboard *Balmoral* and *Waverley* are able to see activity at Tilbury and at the massive London Gateway container terminal.

The 1960s saw the demise of regular pleasure steamer services on the Thames by vessels such as the *Royal Sovereign*. For more than a decade, London only had rare visits by large pleasure boats. It wasn't until the emergence of *Balmoral* and *Waverley* in the late 1970s and 1980s that a traditional service was reinstated.

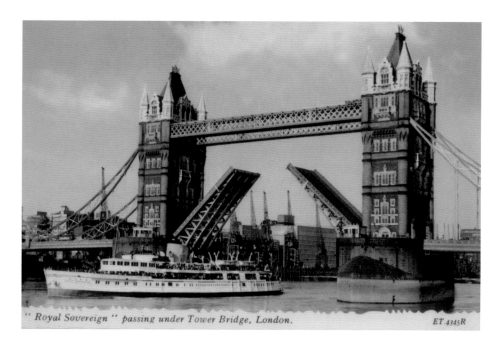

"*Royal Sovereign*" *passing under Tower Bridge, London.* ET.4345R

Royal Sovereign and her sisters the *Queen of the Channel* and the *Royal Daffodil* were the well-loved and famous post-war trio of Thames pleasure steamers that took generations of Londoners to the seaside in those happy post-war years.

Souvenirs were often produced for passengers of the Eagle Steamer fleet. Many showed Tower Bridge in their design. This one is a stamp wallet.

EAGLE
& QUEEN LINE
PROGRAMME

OF DAY
STEAMER
TRIPS
from
SOUTHEND PIER

WHITSUN till MID-SEPTEMBER
1950

EAGLE & QUEEN LINE STEAMERS
Pier Hill — Southend-on-Sea
Telephone: 66597

Pocket programmes were distributed to passengers to promote cruises on the Thames in the 1950s.

The three post-war GSNC vessels, along with earlier vessels such as the *Royal Eagle*, *Golden Eagle* and *Crested Eagle*, were usually moored in front of the Tower of London overnight. Due to their success, the turnaround each day was short.

A novelty souvenir postcard that was purchased by many Londoners in the early 1960s. Recipients were able to transform it into a handy coaster with the help of a pair of scissors. Passengers could buy a wide range of souvenirs aboard the steamers.

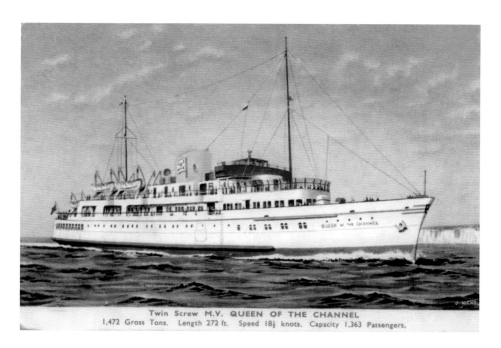

Twin Screw M.V. QUEEN OF THE CHANNEL
1,472 Gross Tons. Length 272 ft. Speed 18½ knots. Capacity 1,363 Passengers.

Queen of the Channel replaced the 1930s motor ship that was lost during the Second World War. She was a magnificent vessel built for pleasure and could carry up to 1,363 passengers. Obtaining a good job on board was important and it was said that bribes were paid to gain a job where there was good potential for tips. It wasn't uncommon for some crew to create their own moneymaking schemes. One ladies' room attendant would usually get off at Gravesend with a heavy carpet bag. It was found that she was charging ladies to 'spend a penny' when the facility was in fact free!

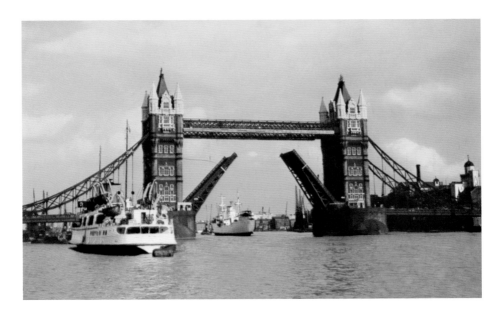

The three post-war GSNC pleasure steamers are still fondly remembered by former passengers. They provided the last great burst of new steamers on the Thames. Unfortunately though, they witnessed the greatest ever challenge to face the steamers when the motor-car revolution occurred. This photograph shows an Eagle Steamer moored in front of the Tower of London ready for a new day of cruising. The pleasure steamers had very little time in which to clean and restock themselves between the return late at night and the departure on another cruise about ten hours later. Around 10 tons of stores such as meat, vegetables, fish, cakes and bread were delivered to each ship each day.

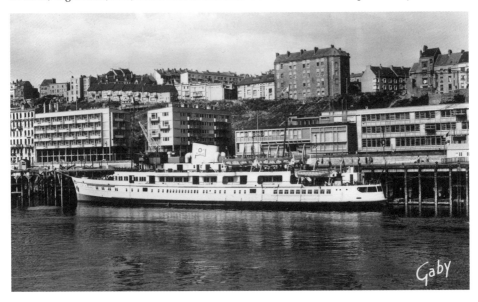

Queen of the Channel at Boulogne. It wasn't until the mid-1950s that the GSNC vessels were allowed to land passengers at Boulogne and Calais, as government regulations only allowed coastal cruises in post-war years. *Balmoral* was the last traditional large pleasure steamer to cross the English Channel to Boulogne in 1993.

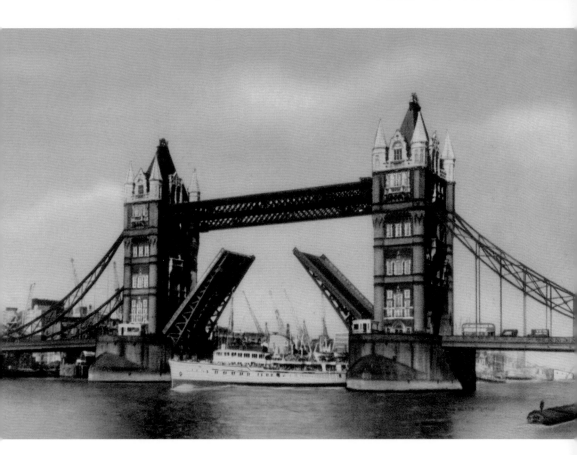

Royal Sovereign at Tower Bridge. The bridge was incredibly busy during the heyday of pleasure steamers when the Thames fleet was at its largest. By 1970, it had become more of a tourist attraction than a working bridge. *Balmoral* and *Waverley* now account for around 10 per cent of annual bridge lifts during each season of cruises.

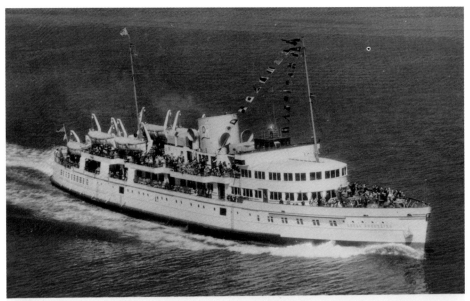

9928. m.v. ROYAL SOVEREIGN.

The mid-1960s saw London's pleasure steamer trade cease. Despite a number of exciting new ventures and brave early attempts at preservation, it was inevitable that nothing could be done. With the rise of preservation societies and a deeper appreciation of heritage just a few years later, there was a surprising change during the 1970s and early 1980s.

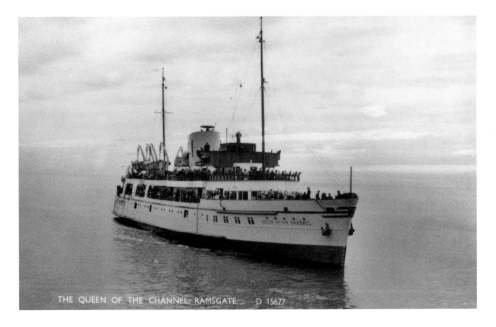

THE QUEEN OF THE CHANNEL, RAMSGATE. D 15677

Queen of the Channel arriving at Ramsgate in Kent. During the 1950s and 1960s, many pleasure steamer services operated from Kent and Essex coastal resorts. Fewer services were offered from London.

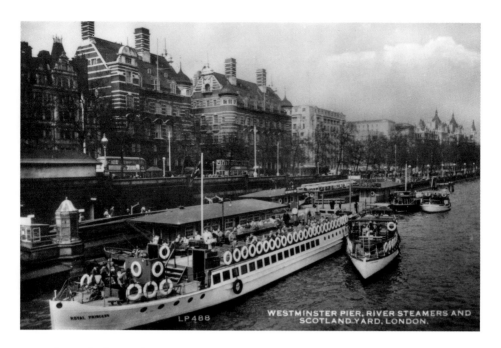

WESTMINSTER PIER, RIVER STEAMERS AND
SCOTLAND YARD, LONDON.

Apart from the large pleasure steamers that have taken Londoners to the seaside from the Pool of London, services have always been popular from places such as Westminster Pier, where sightseeing trips have always been immensely popular. Hampton Court and Richmond have always been immensely sought-after with vessels such as *Royal Princess*.

By the mid-1960s, a day trip aboard a pleasure steamer to the Kent or Essex coasts wasn't as great a draw to Londoners as it was to their grandparents. The rise in car ownership for many Londoners in the mid-1960s helped to spell the death knell for pleasure steamers such as the *Royal Daffodil*, shown here.

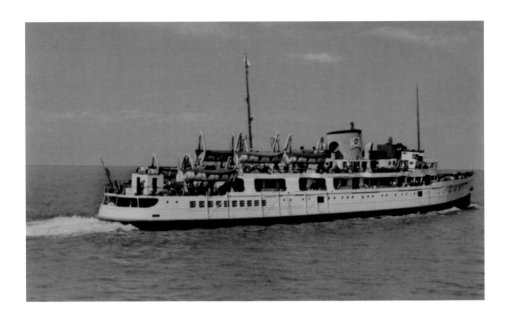

Royal Sovereign, along with her sisters, had side 'blisters' that flared out midships. This gave her the look of a paddle steamer as she was broad at the centre. It enabled large and impressive saloons and dining facilities to be built on the vessel.

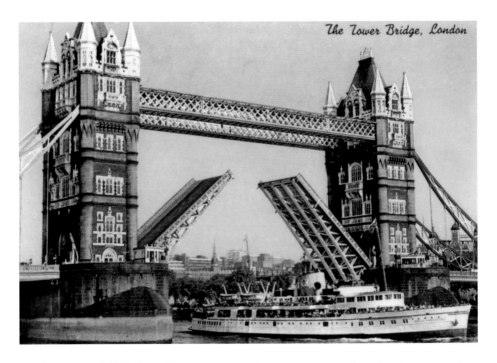

Royal Sovereign, fully laden with passengers on the way to the coast from London in the 1960s. You can appreciate from this view the ample and well-planned deck space that provided plenty of good open accommodation in good weather and enclosed accommodation when weather was bad. Londoners rarely complained on their cruise as it was a special annual treat and they were always determined to enjoy themselves whatever the weather.

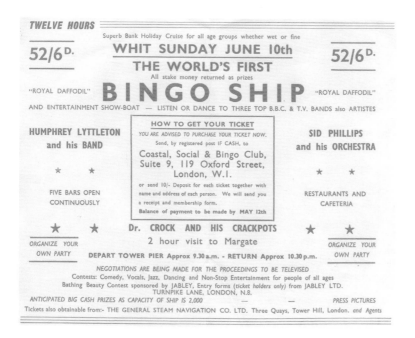

TWELVE HOURS

52/6 D.

Superb Bank Holiday Cruise for all age groups whether wet or fine

WHIT SUNDAY JUNE 10th
THE WORLD'S FIRST
All stake money returned as prizes

52/6 D.

"ROYAL DAFFODIL" **BINGO SHIP** "ROYAL DAFFODIL"

AND ENTERTAINMENT SHOW-BOAT — LISTEN OR DANCE TO THREE TOP B.B.C. & T.V. BANDS also ARTISTES

HUMPHREY LYTTLETON and his BAND

* *

FIVE BARS OPEN CONTINUOUSLY

HOW TO GET YOUR TICKET
YOU ARE ADVISED TO PURCHASE YOUR TICKET NOW.
Send, by registered post IF CASH, to
Coastal, Social & Bingo Club,
Suite 9, 119 Oxford Street,
London, W.1.
or send 10/- Deposit for each ticket together with
name and address of each person. We will send you
a receipt and membership form.
Balance of payment to be made by MAY 12th

SID PHILLIPS and his ORCHESTRA

* *

RESTAURANTS AND CAFETERIA

* * Dr. CROCK AND HIS CRACKPOTS * *

ORGANIZE YOUR OWN PARTY

2 hour visit to Margate

DEPART TOWER PIER Approx 9.30 a.m. - RETURN Approx 10.30 p.m.

ORGANIZE YOUR OWN PARTY

NEGOTIATIONS ARE BEING MADE FOR THE PROCEEDINGS TO BE TELEVISED
Contests: Comedy, Vocals, Jazz, Dancing and Non-Stop Entertainment for people of all ages
Bathing Beauty Contest sponsored by JABLEY, Entry forms (ticket holders only) from JABLEY LTD.
TURNPIKE LANE, LONDON, N.8.

ANTICIPATED BIG CASH PRIZES AS CAPACITY OF SHIP IS 2,000 — — PRESS PICTURES

Tickets also obtainable from:- THE GENERAL STEAM NAVIGATION CO. LTD. Three Quays, Tower Hill, London. and Agents

Were you on board the *Royal Daffodil* with Dr Crock and his Crackpots in the 1960s? Did you win a prize at bingo or listen to Humphrey Lyttleton and his band? General Steam Navigation did a great deal in the early 1960s to provide entertainment for their dwindling clientele. Despite such enticements being a great alternative to the traffic jam, services (and bingo) ceased in 1966.

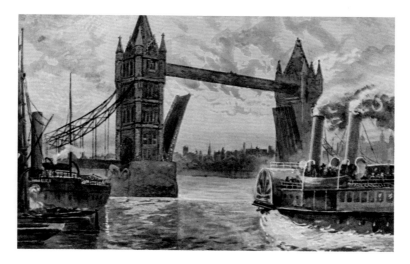

A day trip to the seaside was a hugely enjoyed treat for many generations of Londoners. It was said that, for many, the trip became one long drinking session and that many East Enders would say that they'd had a great time despite never moving from the bar! The excitement of arriving back at London's Tower Bridge ensured that the most lubricated passengers quickly went ashore happily.

Queen of the South manoeuvring close to Tower Pier on 28 May 1966. *Queen of the South* was a valiant early attempt at preserving a paddle steamer on the Thames. She was built in 1931 for service on the Firth of Clyde as the *Jeanie Deans,* but was withdrawn in the early 1960s due to declining trade. Her arrival on the Thames coincided with the final months of the majestic General Steam Navigation Company.

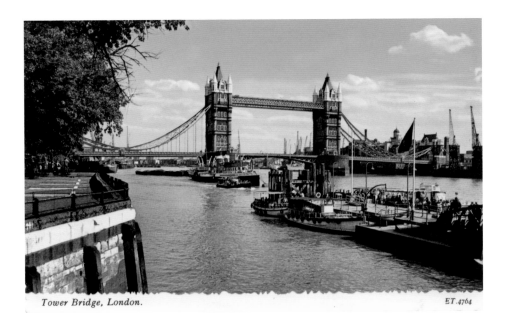

Tower Bridge, London. ET.4764

Queen of the South tied up in front of Tower Bridge in the mid-1960s. This steamer looked spectacular on the London River but never gained popularity due to her many mechanical break-downs and the fact that she appeared at the very worse time. If she'd arrived ten years later, things may have been very different.

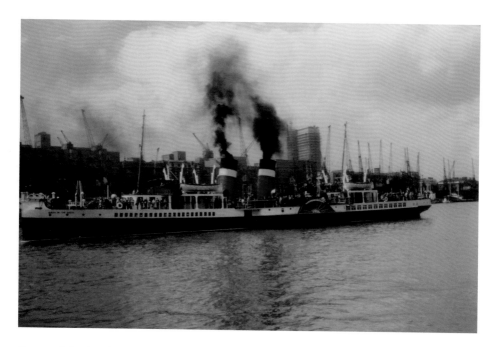

Queen of the South passing a London river landscape that has disappeared during the past fifty years. Guy's Hospital was being built at the time and cranes can be seen at the top of the building. The wharves and cranes have now gone and have been replaced with designer shops and restaurants. Finally, the Shard is the biggest difference. Its 1,900-foot viewing platform was unthinkable back in 1966.

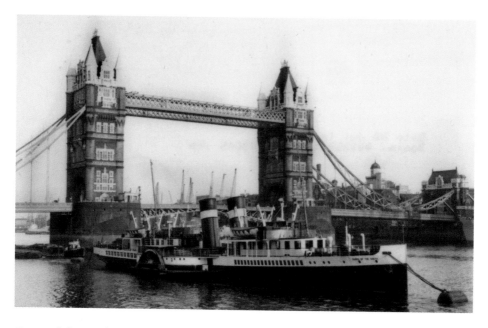

Queen of the South was refitted in Tilbury docks ready for her career on the Thames. Her career was one of the shortest of any London steamer. It was also one of the most negative and dramatic due to the myriad problems that surrounded her.

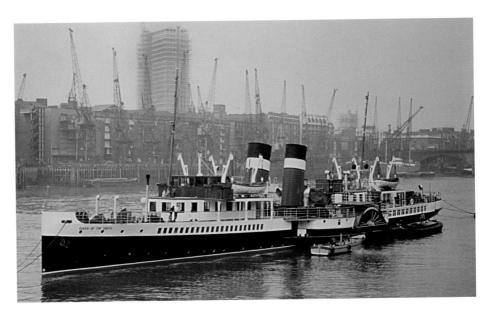

Queen of the South in a pose that was linked with her – tied up, inactive on the buoys in the Pool of London. The vista around her is very different to that of today. The Thames-side wharves and cranes have been replaced with trendy cafes. On the right you can see the old London Bridge. Guy's Hospital is also being built in the distance.

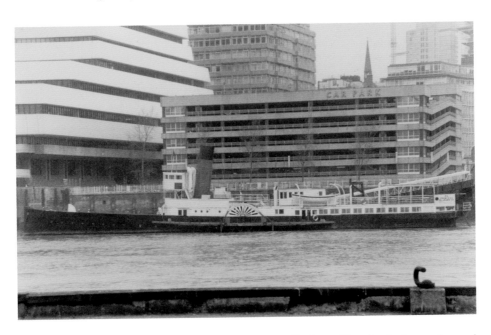

Princess Elizabeth moored at London in April 1976. All of a sudden, in the late 1960s and 1970s, once-famous paddle steamers took on a static role in London as the fleets around the coastline of the United Kingdom disappeared. London was lucky in many respects, as some of the most famous pleasure steamers in Britain suddenly appeared at the capital. Their London careers were usually spectacularly short due to the maintenance costs for what were elderly and run-down vessels.

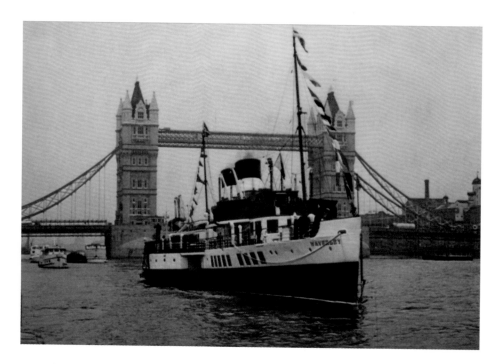

Waverley arriving at London Tower Pier for the first time in 1978. She had travelled south for the first time a year earlier as passenger trade on the Clyde was insufficient to keep her going. Her arrival at London on that day marked a wonderful achievement for her many supporters. Since 1978, she has become 'London's Paddle Steamer.'

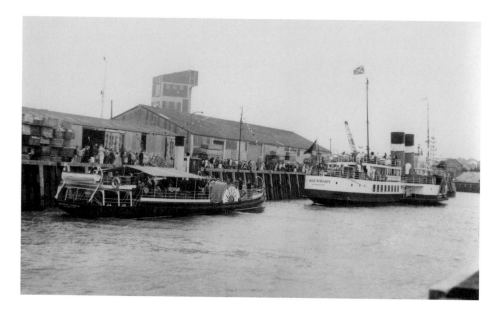

Waverley (right) and *Kingswear Castle* (left) at Whitstable harbour in 1985. Their annual visits to the Kent fishing town were an annual feature of their timetables for over twenty years. Whitstable continues to be one of the most popular destinations for Londoners in the twenty-first century.

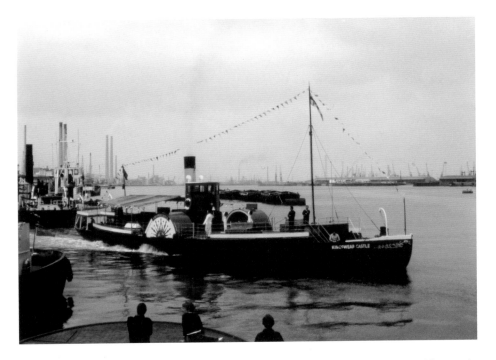

Kingswear Castle departs from the Royal Terrace Pier at Gravesend on one of her early visits to London and the Thames in the mid-1980s. She always took part in the annual 'Gravesham Edwardian Fair' before heading for London.

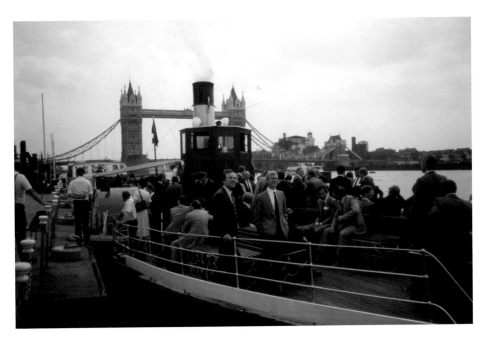

Kingswear Castle alongside London Tower Pier with a full loading of passengers. When she visited London in the 1980s and 1990s she usually had at least one major charter. She has carried many famous passengers including Margaret Thatcher and HRH Prince Edward.

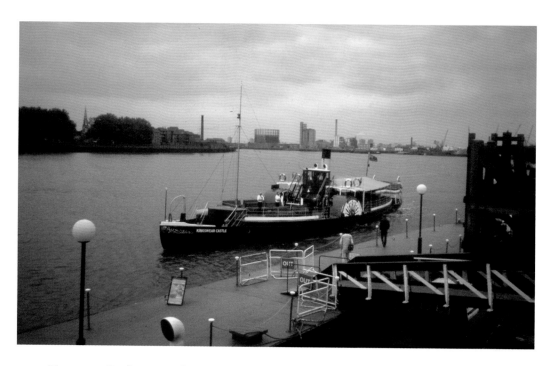

Kingswear Castle approaching Greenwich Pier. She is a stark opposite to the Clipper catamarans that inhabit the Thames today. She is more in keeping with the distinctive fleet of London County Council paddle steamers of Edwardian times.

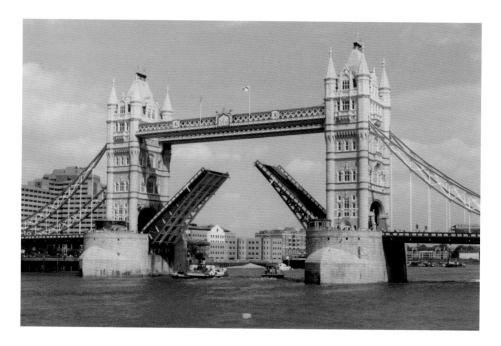

Kingswear Castle passing under Tower Bridge in the early 1990s. She had a highly profitable career on the Thames and Medway for almost three decades. While in London she usually used London Bridge City Pier. She can carry up to 235 passengers and is still fired by coal.

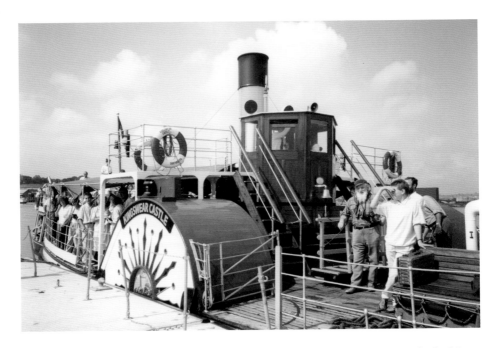

Kingswear Castle was a familiar visitor to the London River for many years. She had been painstakingly restored by a group of loyal volunteers on the nearby River Medway. She would visit London most summers from the mid-1980s onwards. This would usually involve a single trip to London from Gravesend, as well as a trip or two from London Bridge City Pier.

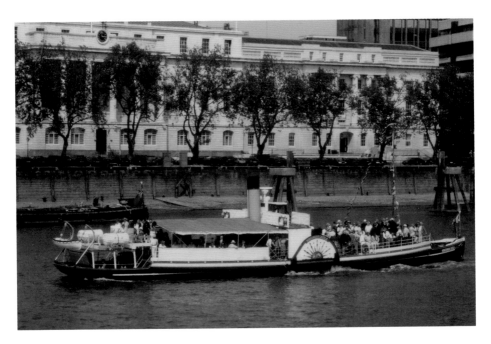

Kingswear Castle was a frequent visitor to London for many years. She plied successfully on the Medway and Thames from 1985 until 2012 and gained a huge numbers of dedicated fans. She was then taken to the River Dart.

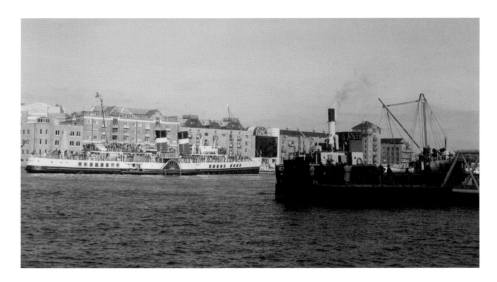

Waverley departing from London on 6 October 1994. She's passing Butler's Wharf. A traditional Clyde Puffer is in the foreground. By the 1990s, *Balmoral* and *Waverley* had developed timetables that revived popular cruises from the past as well as attending special events such as the centenary of Tower Bridge that year.

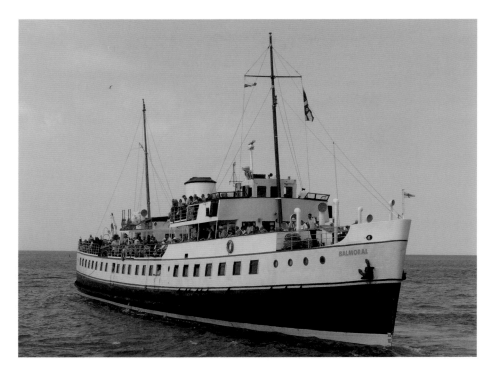

Balmoral has now visited the Thames for around thirty years and has became a firm favourite for a generation of Londoners. Her role in keeping open piers and ports to pleasure steamers is hugely important. In 2015, she embarked upon an exciting new educational cruise role. This will enable future generations of Londoners to appreciate the heritage of the River Thames and its ships.

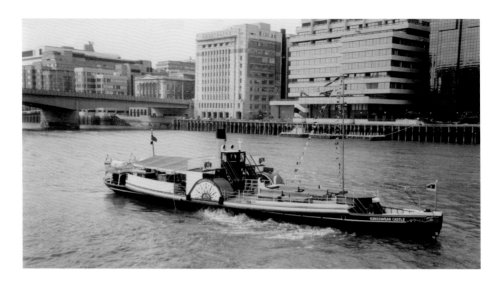

Kingswear Castle was built in 1924 for service in Devon. After years of neglect and uncertainty, she was restored for service once again in the 1980s. She is seen here on one of her regular visits to London, manoeuvring to go alongside London Bridge City Pier. Behind her you can see where paddle steamers operated from in the days before Tower Pier was built.

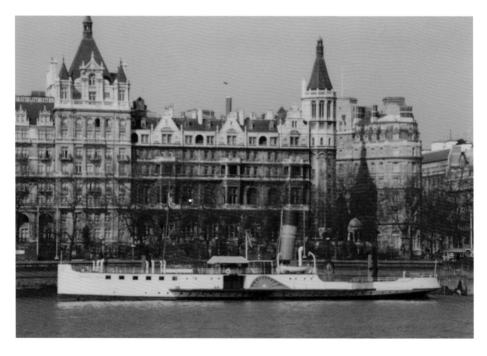

What a difference a livery makes! The *Tattershall Castle* is seen here on 8 April 1976 in a livery that is very different to her dark-blue one of the twenty-first century. Note also that large viewing-windows have now been inserted into the hull towards the bow to give diners a better view. She certainly has a spectacular view of the London skyline since the construction of the London Eye opposite her.

Tattershall Castle has been a London landmark since the late 1970s. She was originally a Humber paddle ferry and was transformed into a restaurant and bar for the Thames after withdrawal. She is moored close to Charing Cross railway station and is a popular place for Londoners to relax after a day at the office as her spacious decks offer spectacular views of the London Eye, Houses of Parliament and Westminster Bridge.

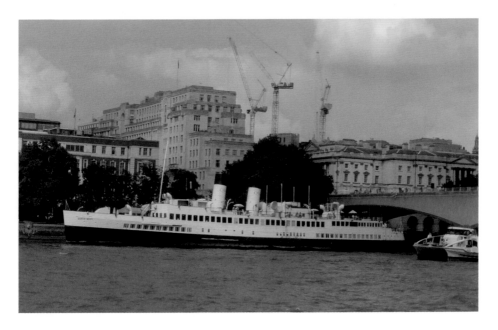

The *Queen Mary* was a familiar sight on the Thames for two decades. She was a famous Firth of Clyde pleasure steamer. After her withdrawal she was converted into a floating restaurant and bar and moored outside the Savoy Hotel. Many old pleasure steamers from around Britain have found a retirement home in London. The most famous of these was the *Caledonia*, which was moored in roughly the same position as the *Queen Mary*. She was destroyed by fire in 1980.

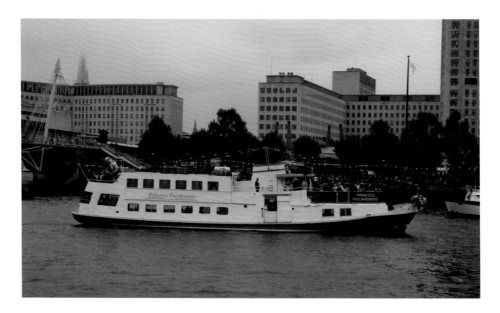

Princess Pocahontas has been part of the London pleasure-cruising scene since 1989. During each season she operates popular cruises from Gravesend to London to view the capital's amazing waterfront. She is shown here taking part in the spectacular Queen's Diamond Jubilee River Pageant in 2012. The event saw a huge collection of the United Kingdom's pleasure steamer fleet parade alongside Her Majesty the Queen.

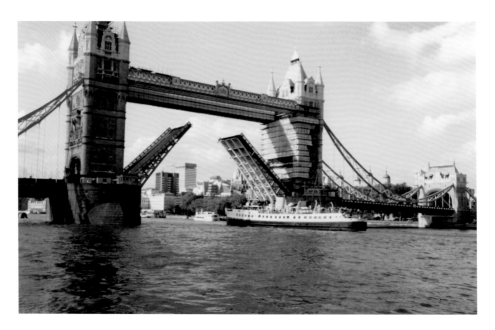

Balmoral passing under the raised bascules of Tower Bridge around 1992. *Waverley* and *Balmoral* now account for around 10 per cent of the total number of lifts of Tower Bridge. The bridge has seen extensive renovation work over recent years. This has included state-of-the-art LED lighting that spectacularly changes to enchant passengers aboard pleasure steamers of the twenty-first century as they finish their cruise.

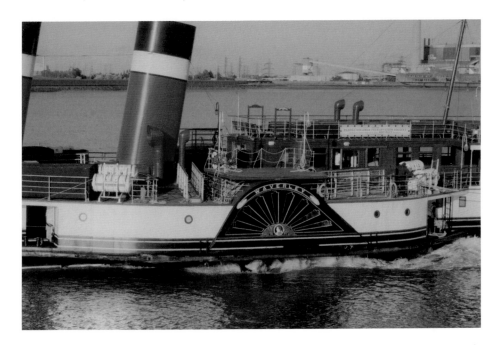

Waverley departing from the Town Pier at Gravesend for London. Trips to the capital city from places such as Gravesend, Southend, Margate and Whitstable remain immensely popular in the twenty-first century. The riverside developments on the Thames provide an ever-changing vista for passengers.

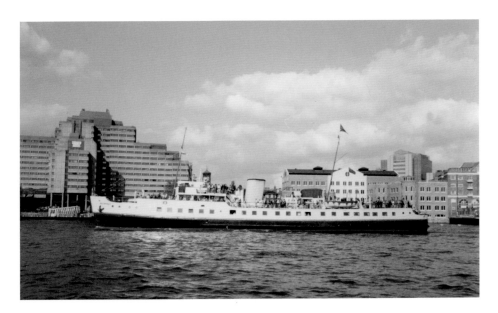

The famous *Balmoral* has acted as *Waverley's* much-needed consort for almost thirty years now. She has visited the Thames regularly since 1987 and is seen here passing the Tower Hotel in around 1992. She's now the most famous operational vessel of the Red Funnel fleet of Southampton to survive, and is on the United Kingdom's Core Collection of historic ships.

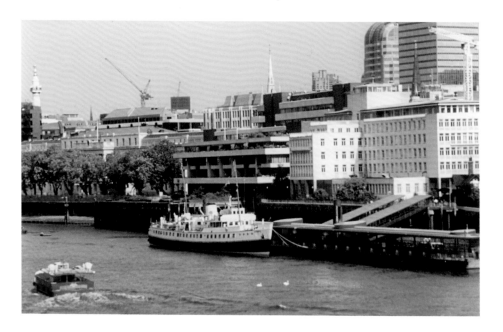

Balmoral alongside Tower Pier. The pier was totally rebuilt at the time of the Millennium. The new facilities were built to accommodate tenders to and from visiting cruise liners to the Pool of London, as well as to provide modern facilities for the Clipper Catamaran services. *Balmoral* and *Waverley* are usually berthed overnight at the pier at weekends during their visits.

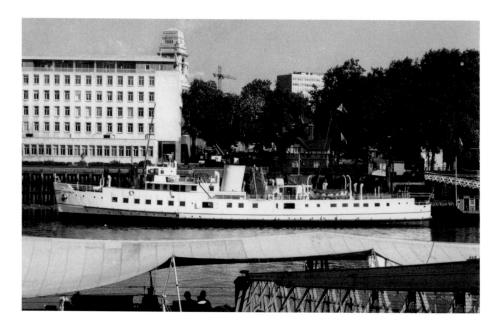

Balmoral at London Tower Pier on 25 September 1987. This was her first visit to the Thames and Londoners were delighted with her appearance and facilities. She has visited the Thames every year since 1987 and a timetable was created that utilised her full potential on the Thames, as she could get to locations that *Waverley* couldn't.

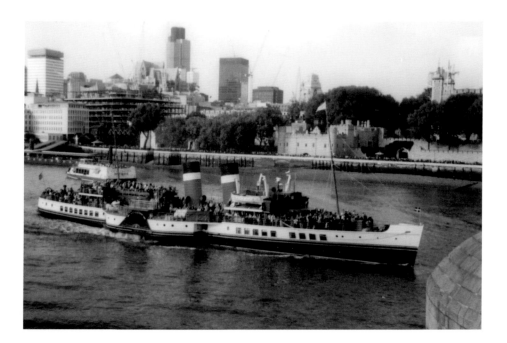

Waverley passing the Tower of London around 2003. The Tower has remained an unchanging feature in a landscape that pre-war Londoners would hardly know. You can see the sandy banks in front of the Tower in this view. In pre-war days, Londoners would use this area as their beach – they sat in deckchairs while their children built sandcastles and their more affluent friends passed by on vessels such as the *Royal Eagle*.

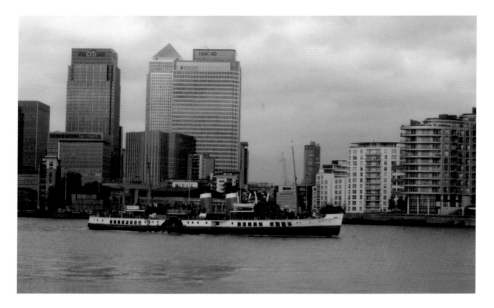

Waverley passing the Canary Wharf towers in October 2010. The Isle of Dogs and indeed most of London's riverbank architecture has changed tremendously since the 1970s. It's a world far removed from the business of the London docks of the British Empire. *Waverley* herself has seen tremendous changes on the Thames since she first arrived in 1978.

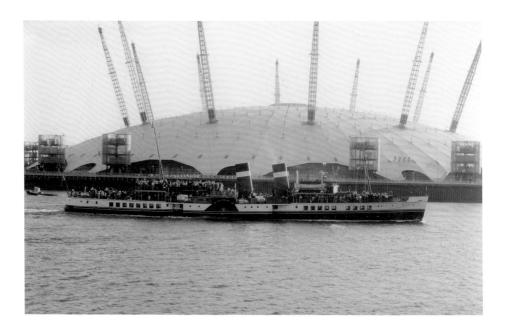

The cruise to London from places such as Southend, Margate and Gravesend is proving immensely popular in the twenty-first century. Thames-side buildings and vistas that were familiar to generations of Londoners, such as the London docks and wharves, have been replaced with equally impressive modern buildings such as the Millennium Dome. Its impressive list of statistics provides great entertainment in commentaries!

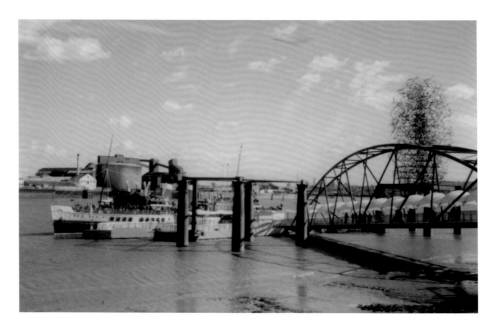

In 2000, Londoners were able to travel to and from the Millennium Dome by *Waverley* to view the exhibits in the controversial attraction. The cruises were as popular as the attraction itself! Londoners and commuters still use the Dome Pier as it is a regular calling point for the Thames Clippers.

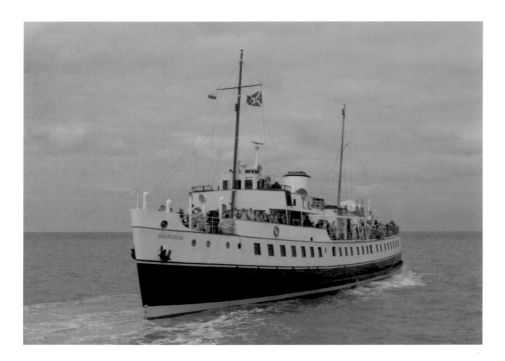

The *Balmoral* has been a Thames favourite for Londoners since 1987. She is of traditional design and her early livery was close to that of the famous post-war pleasure steamers of the Eagle Steamer fleet. In January 2015 she was awarded major funding to keep alive the tradition of coastal cruising for future generations to enjoy.

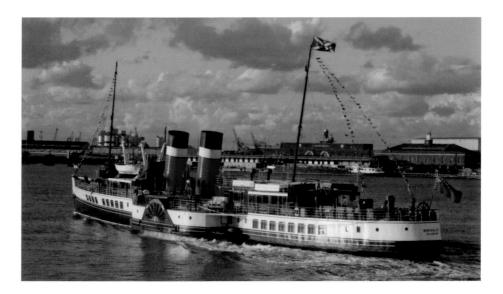

Waverley departing the Town Pier at Gravesend for London Tower Pier in October 2012. *Waverley* received a major heritage rebuild in 2000 to enable her to comply with new safety regulations and to return her to her pristine 1947 condition. She's not only the last of the Firth of Clyde paddle steamers, but also the last of the Thames paddle steamers.

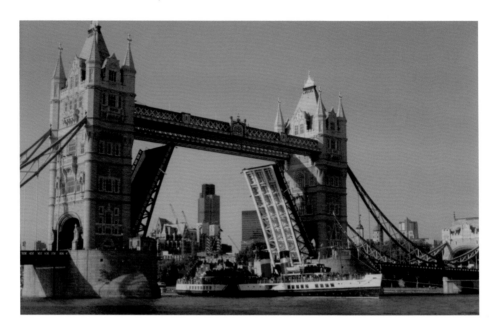

London passengers aboard the *Waverley* in 2014. *Waverley* has been a well-loved feature of each autumn for over thirty years. Her Thames career is now greater than most of the famous Thames steamers of the past.

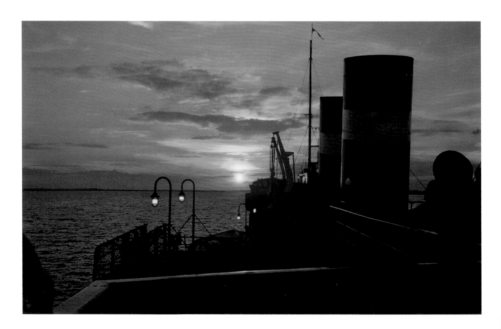

A sight that has welcomed passengers aboard pleasure steamers for almost 200 years as *Waverley* paddles home to London at the end of a cruise to the seaside. The return up the Thames heads into the setting sun and splendid sunsets can be appreciated on the deck of the steamer. The finale is of course seeing Tower Bridge open for pleasure steamers such as *Balmoral* to pass under. There's still no finer way to appreciate the heritage and landmarks of the River Thames.